LOST EDINBURGH

IN COLOUR

LOST EDINBURGH
IN COLOUR

—— LIZ HANSON ——

AMBERLEY

First published 2014

Amberley Publishing
The Hill, Stroud, Gloucestershire, GL5 4EP

www.amberley-books.com

Copyright © Liz Hanson, 2014

The right of Liz Hanson to be identified as the Author of this work has been
asserted in accordance with the Copyrights, Designs and Patents Act 1988.

ISBN 978 1 4456 3497 5 (print)
ISBN 978 1 4456 3518 7 (ebook)

British Library Cataloguing in Publication Data.
A catalogue record for this book is available from the British Library.

Typesetting by Amberley Publishing.
Printed in the UK.

INTRODUCTION

The topography of Edinburgh renders it unique as a subject for a 'lost' city. The city grew up on a mile-long sloping tail between the volcanic rock crag, on which the Castle stands, and Holyrood Abbey at the lower eastern end. This natural feature, cluttered with medieval high-rise buildings, is as recognisable to twenty-first-century eyes as it was to Oliver Cromwell in 1650, or Charles Edward Stewart in 1745. Superficially, it appears unaltered by time, and a walk down the High Street captures something of the atmosphere – albeit sanitized – of old Edinburgh. In reality, many buildings have disappeared due to war, fire, decay or demolition, but the essential heart is still beating and alive with shops, businesses, residences and thousands of tourists.

The 360 degree panorama from the castle rock made the elevation an obvious defensive vantage point for fortifications in early times, but the first records date from the late eleventh century. Malcolm III ruled Scotland for thirty years until he was succeeded by his son, David I, who was responsible for founding both Holyrood Abbey in 1128 and the burgh of Edinburgh in

1130. Shortly after, he allowed the Augustinian canons to have their own separate burgh, Canongate, and it was between here, at the foot of the ridge, and the royal residence in the castle at the top, that Edinburgh developed.

Initially, single dwellings were erected side by side on strips of land (known as tofts), which were at right angles to the main thoroughfare. Over time, as more houses were required, the back land was built up, with access via narrow passageways or closes. These provide fascinating and atmospheric features to this day. There were physical limitations to expansion – the valley to the north of the ridge led down to a swamp, and beyond the town walls to the south was the densely wooded Burgh Muir.

The history of Edinburgh was dominated for six centuries by fractious relations with England, and cross-border incursions occurred with alarming regularity. In the early thirteenth century, the Scots, led by Alexander II, invaded England, hoping to take Northumberland, but this was unsuccessful. His eight-year-old son, Alexander III, became king in 1249. Although he managed to win back the Western Isles from Norse influence,

his reign was beset with tragedies, including the deaths of all his children. When he died in a severe storm in 1287, travelling from Edinburgh to Fife, there was no obvious successor, but plenty of claimants to the crown. The ambitious Edward I, already having successfully invaded Wales, came to Edinburgh Castle to arbitrate, though, in reality, he saw an opportunity to be overlord of Scotland too. He treated the Scots so badly that they looked to France for support (the Auld Alliance), a move that led Edward to sack Berwick and remove the Stone of Destiny and regalia from Edinburgh Castle. The rebellion against the 'Hammer of The Scots', as he became known, led to the Wars of Independence. In 1314, Robert the Bruce defeated the army of Edward II at Bannockburn, gaining independence for Scotland in 1328. He also granted Edinburgh a charter to be a royal burgh. His son, David II, was responsible for building David's tower, a massive four-storey edifice, to fortify the castle.

The colourful Stewart dynasty began with James I in 1424. He was kidnapped and exiled in England, only to find that in his absence the Scottish court had become rife with corruption and internal fighting. A bloody and murderous period followed, until James IV came to the throne in 1488, heralding a respite from war and a period of creativity. He favoured art and science and was patron of the first printing press in Edinburgh, a profession that eventually flourished in the city. The guest accommodation at the abbey was converted to the royal residence of the Palace of Holyroodhouse, the College of Surgeons was founded and a Scottish Navy was formed. To complete this relatively peaceful time, James married Margaret, Tudor princess and daughter of Henry VII. Then, in 1513, came the disaster of Flodden and the death of James IV.

By this time, Edinburgh had swollen to 12,000 citizens living within the town walls (the extended defence of Flodden Wall was built after the battle). The thoroughfare between the royal residencies of the castle and Palace of Holyroodhouse became known as the Royal Mile. This consisted of Castlehill and Lawnmarket, where the burgh church of St Giles was situated, before leading to the eastern gate out of the town – Netherbow Port – into Canongate. Grassmarket and Cowgate, in the valley south and parallel to the Royal Mile, had become suburbs within the walls. The Craig Burn, in the valley below the northern slope of the burgh, was dammed to create the Nor' Loch, which provided both water and defence, although that gradually became rank and polluted over the years. The only choice was to build upwards, adding more storeys to existing houses, creating steep, narrow and dark closes, or wynds, between them. During the sixteenth century, tall tenements, known as 'lands', became part of Edinburgh's streetscape. Wealthy citizens often had country houses in the hinterland, outside the walls, by this time.

European religious reform spread to Scotland during the early sixteenth century, a very turbulent episode in Edinburgh's history. At this time, the infant (and Roman Catholic) Mary, Queen of Scots was the choice of Henry VIII for marriage to his Protestant son, a decision motivated by a fear of his European enemies landing in Scotland to invade from the north. The guardians refused this request, and the king's wrath was played out by the Earl of Hertford and his army, who burnt and devastated the Borders and Edinburgh. 'The Rough Wooing' meant that much of the Old Town had to be rebuilt. The Protestant movement, led by John Knox, became increasingly

hostile to the queen, who abdicated in 1568 in favour of her son, James IV, who became James I of England in 1603. He wished to unite the crowns to form Great Britain.

Religious dissent reared its head once more in the seventeenth century, when Scottish Presbyterians locked horns with Charles I, who was crowned in St Giles, and who insisted that the Anglian prayer book be used in Scotland. Civil unrest ensued, and a national covenant was drawn up by a lawyer and a minister in Edinburgh, which thousands of people signed. The Covenanters episode, fuelled by religious fervour, was bloody, and public executions from both sides took place in the capital. However, there were improvements to the burgh too. Charles I was responsible for the decision to build Parliament House behind St Giles, enabling the council, the Court of Sessions and Parliament to have their own premises, rather than meeting in the disgusting Tolbooth. Also, the first of the charitable schools – George Heriots Hospital – was erected, paid for by an endowment from the goldsmith of that name.

The eighteenth century began badly. The nation was economically weak after a succession of civil wars, poor harvests and difficulties with international trading. The Company of Scotland was established in 1696, with the idea of colonising an area in Panama, from where it could trade across both the Atlantic and the Pacific, and thus solve the financial woes. The Darien Scheme was a disaster and almost bankrupted Scotland, precipitating not just civil unrest, but also sealed the nation's history. The Treaty of Union was signed in 1707. The issue of independence for Scotland is currently being put to vote in a referendum.

In 1745, the Jacobite uprising saw Charles Edward Stewart arrive in Edinburgh, where he was given a good welcome, but the war-weary citizens had no appetite for further conflict and did not volunteer to join his troops. The next day he defeated the Hanovarians at the Battle of Prestonpans, but the Stuart dynasty ended at the Battle Culloden in 1746.

As the eighteenth century progressed, Edinburgh underwent radical and rapid changes – physically, socially and culturally. The Old Town was impossibly overcrowded, noisy and filthy, and improvements were desperately needed. The idea of expansion was being discussed, primarily by George Drummond, (Lord Provost six times between 1725 and 1764). This began with the publication of a pamphlet entitled 'Proposals for carrying on Certain Public Works in the City of Edinburgh'. A small-scale development started to the south, but the greatest change came when the North Bridge was built across the valley from Old Town to the countryside beyond, on which was built the New Town. The elegant, linear layout was influenced by an era of Scottish Enlightenment, and contrasted starkly with the chaos of old Edinburgh. In 1785, the construction of South Bridge, spanning Cowgate, allowed development to spread southwards. During the Victorian era, great streets grew up over the old Burgh Muir, an area which became known as the south side.

In the twentieth century, the city boundaries were extended to encompass surrounding villages and the port of Leith, and its population now stands at 480,000. It is renowned for education, medicine, law and financial services, and is known worldwide for its International Arts Festival. Both the Old and New Towns are listed as UNESCO World Heritage sites.

BIBLIOGRAPHY

Daiches, David, *A Traveller's Companion to Edinburgh*.
MacGregor, Alastair Alpin, *Auld Reekie*.
Coghill, Hamish, *Lost Edinburgh*.
Groome, Francis, *Ordnance Gazeteer of Scotland*.
The Life Association of Scotland.
Cant, Malcolm, *South Edinburgh*.
Gifford, McWilliam & Walker, *The Buildings of Scotland: Edinburgh*.

Grant, James, *Old and New Edinburgh, Vols 1–3*.
Geddie, John, *The Fringes of Edinburgh*.
Macdonald, Sir J. H. A., *Life Jottings of an Old Edinburgh Citizen*.
Chambers, Robert, *Traditions of Edinburgh*.
Smith, Charles J., *Historic South Edinburgh*.
Scott, Bill, *The Buttercup*.

ACKNOWLEDGEMENTS

I would like to thank the following people for their assistance in compiling the book. Thanks to Alison Stoddart at Capital Collections for her assistance and for allowing the use of images on pages 8, 55, 63, 64 and the front cover. Thanks also to Peter Stubbs at Edinphoto, Margaret Maxwell, Bill Scott, Malcolm Cant and Frank Hay.

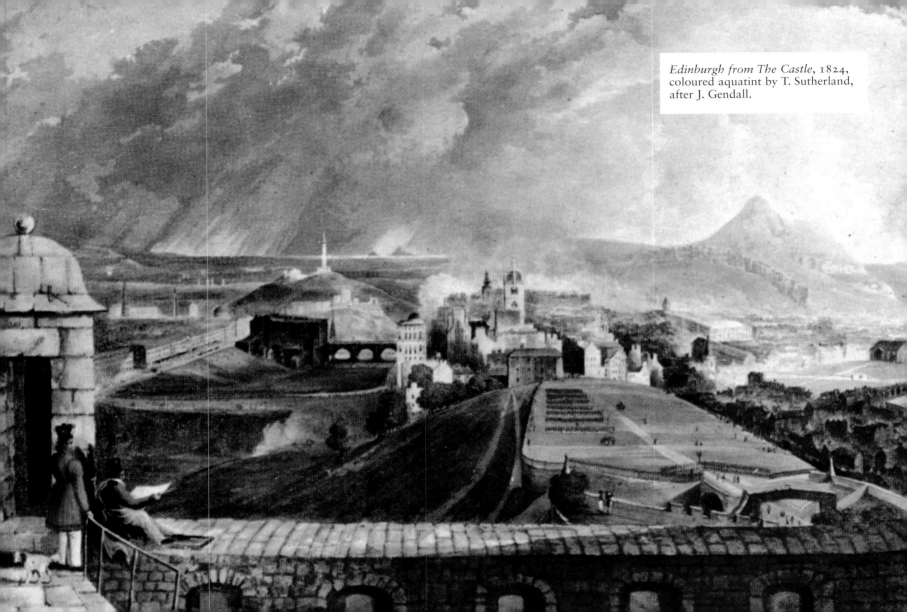

Edinburgh from The Castle, 1824,
coloured aquatint by T. Sutherland,
after J. Gendall.

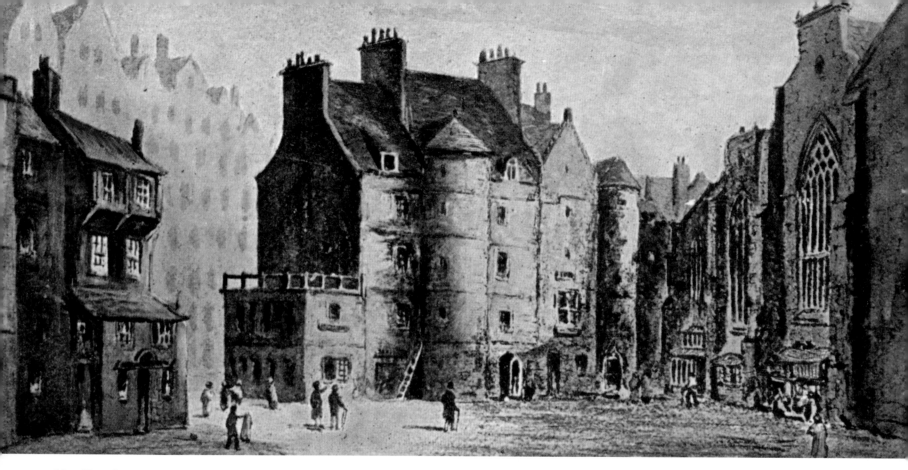

Old Tollbooth

This was the most feared destination in Edinburgh. It would have been a treasure to retain, but it jutted out at an odd angle into Lawnmarket, impeding traffic, and had become a dilapidated, disgusting and malodorous hovel. It was pulled down in 1817, when Calton Jail was opened. It had been used variously for meetings of the court, town council and parliament, until the purpose-built Parliament House was completed in 1640, after which time it was purely a jail. Prisoners were held there awaiting execution, which traditionally took place at Grassmarket, Castlehill or at the Mercat Cross. In 1785, a high platform was built on the side of Old Tollbooth, designed for hangings. Walter Scott, who collected Edinburgh memorabilia, took the redundant door to Abbotsford House ,and was responsible for naming the building 'Heart of Midlothian'.

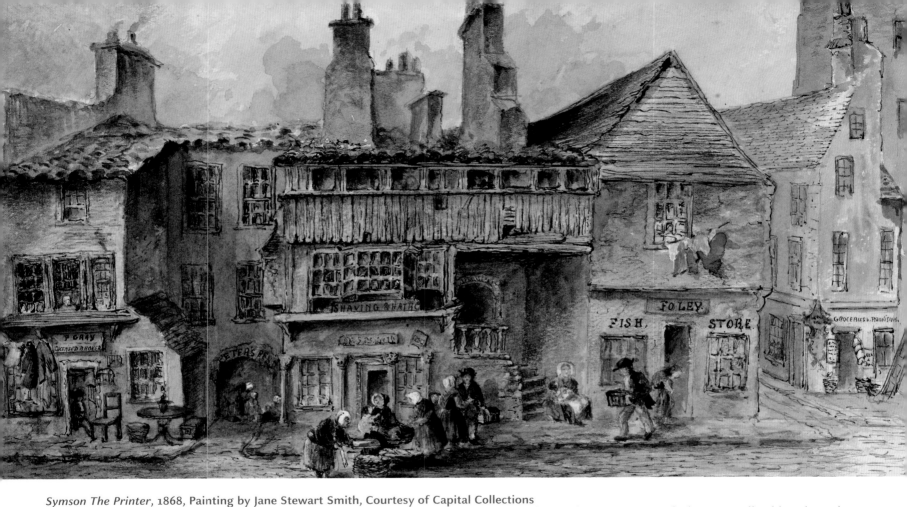

Symson The Printer, 1868, Painting by Jane Stewart Smith, Courtesy of Capital Collections

Cowgate runs parallel to the Royal Mile, but lies in the valley to the south, leading to Grassmarket. Both areas were outside the town walls, although was later enclosed by Flodden Wall. It was so named because livestock was brought from the countryside by this route to market. By 1500, most of the High Street and Canongate were built up, so residents overflowed into Cowgate and it became quite a fashionable area in the seventeenth century. Andrew Symson, a former Church of Scotland minister from Wigton, opened a printing house at the foot of Horse Wynd, around 1697. It is worth noting the architecture of the time, particularly the timber frontages, which, although attractive to modern eyes, were prone to fire damage and eventually replaced with stone.

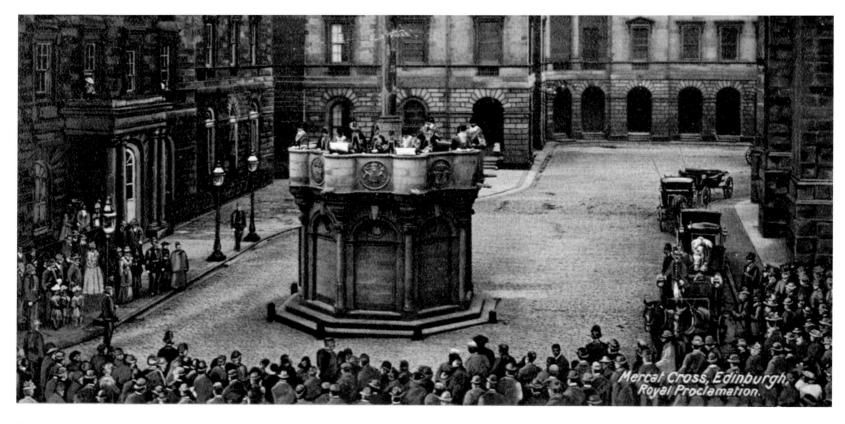

Mercat Cross, Edinburgh, Royal Proclamation.

Mercat Cross

The charter of 1365 describes the Mercat Cross as being located downhill from St Giles. In 1617, it was moved further down the High Street, near Fishmarket Close, where an octagon of cobbles now commemorates the site. The years before it reached its current location were eventful – it was broken up in 1756 and the pieces taken to Drum house, where it remained for 130 years until, in 1885, the Prime Minister, William Gladstone, paid for its restoration. In the meantime, Walter Scott had procured a few of the ornamental medallions, which are incorporated into a wall at Abbotsford, and another part of the old cross is preserved in a Barnton garden. The Mercat Cross of today is somewhat smaller than the original, and only the capital dates to the fifteenth century. The photograph is from 1906, when the Liberal Party won the general election.

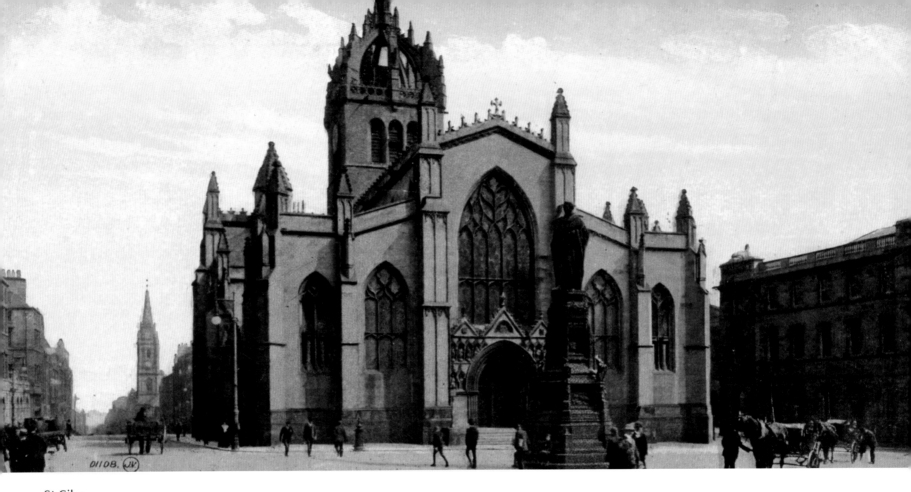

St Giles
This was the sole burgh church of medieval Edinburgh, and the majestic crown spire belied the chaotic scene that surrounded the walls below. As well as the hive of activity in and around the adjacent Old Tolbooth, the church was surrounded by market traders selling their wares from luckenbooths (locked stalls), as well as other open stalls lining the street. The churchyard behind it extended to the declivity of Cowgate, but, as with all aspects of life, space was at a premium, and after the Reformation, the gardens of Greyfriars monastery were instead used for burials. Today, the High Kirk of Edinburgh today stands in isolation in Parliament Square.

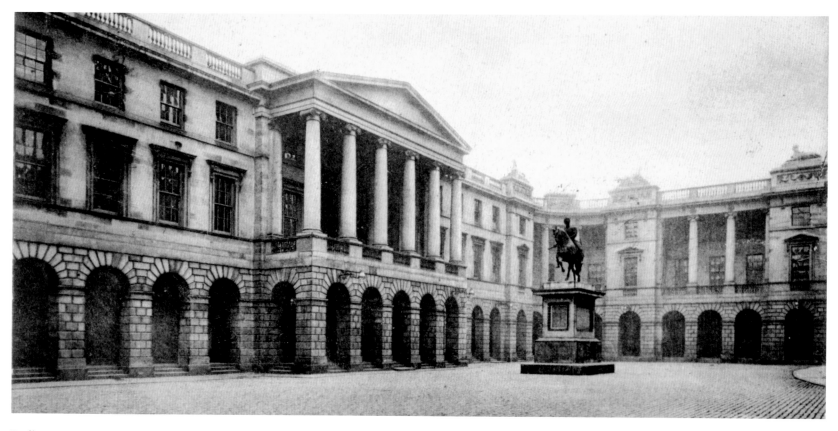

Parliament House
The present building, housing the Supreme Courts of Scotland, replaced the one from 1640, which was used for 170 years, and was considered to be a more attractive building than its successor. Prior to the construction of the first one, arrangements for the Parliament were most unsatisfactory, as they shared the Tolbooth not only with prisoners, but with the court and town council. Eventually, chronic overcrowding led to part of St Giles being used as a meeting place, but, when the judges threatened to move the Scottish judiciary to St Andrews, Charles I instigated the provision of a dedicated Parliament building on the site of manse houses, south of the church. The Treaty of Union in 1707 meant that the government sat in London, until the devolved Scottish Parliament (1999) moved to their new building at Holyrood in 2004.

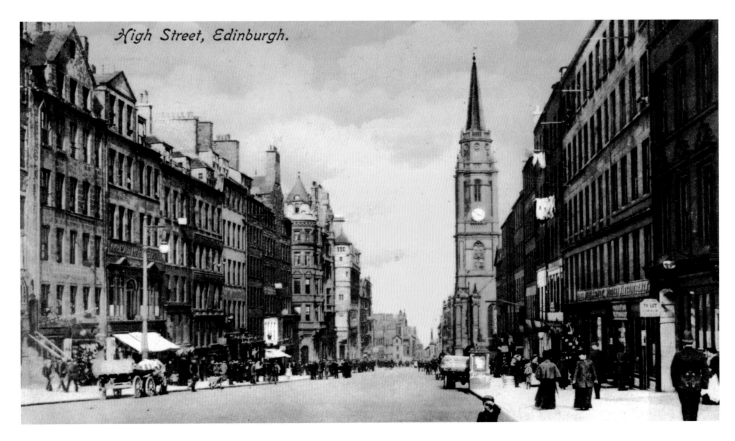

High Street, Edinburgh.

High Street, Lawnmarket

It is difficult to imagine how congested this part of High Street was before New Town was developed in the late 1700s. Lawnmarket – or land market – as the name suggests, sold farm produce from open stalls lining the street below the tall tenements, while, a few yards away, the wooden luckenbooths (locked stalls) were crammed together around the walls of St Giles, (they were finally cleared away in 1817). In deference to the ecclesiastical site, the latter were utilised by 'respectable' traders, such as booksellers or goldsmiths. Residents, shoppers, beggars, judges, nobility and merchants all rubbed shoulders as they jostled to make their way through the narrow gap between these obstructions. Even the busiest day of the Edinburgh Festival Fringe could not compare with seventeenth-century Lawnmarket.

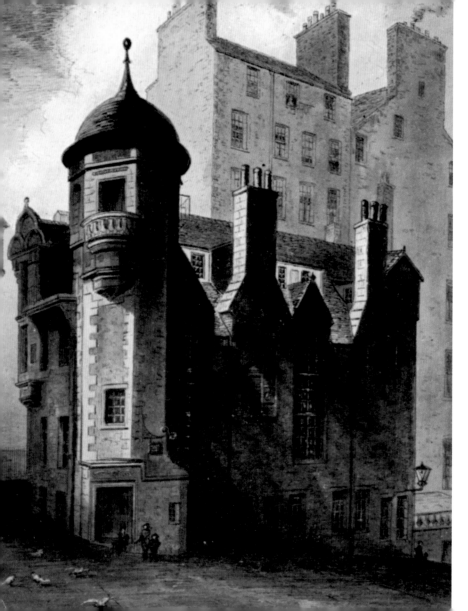

Lady Stair's House

This house was built in 1622, in Lady Gray's Close, by a wealthy merchant, Sir William Gray. He sold it to the first Earl of Stair, whose widow bought the house in 1719. She had a terraced garden at the back, which sloped precariously down to the shore of Nor' Loch. The close was used as a shortcut through to the unfinished Mound, before Bank Street was made up as part of Edinburgh's improvements. Lord Rosebery, a descendant of Lady Stair, purchased it in 1893 and, once renovated, gifted it to the nation.

Riddell's Close

The court at the southern end of the close has a house that was built for Baillie McMorran, a wealthy merchant, in 1590, and is an excellent example of the contemporary architecture. Scottish Historic Buildings Trust is currently involved in a restoration project of the property, which will become home to The Patrick Geddes Centre for Learning and Conservation. However, a significant number of adjacent buildings were lost during the slum clearance in 1893, including those lining the two closes leading to Cowgate and West Bow, and most of the northern courtyard.

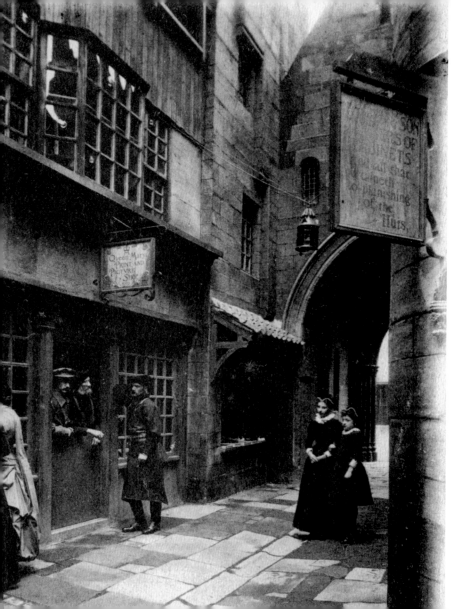

Mary of Guise Oratory
Wife of James V and mother of Mary, Queen of Scots, she acted as Regent for her daughter between 1554 and 1560, at which time she lived in a palatial house on Castlehill, safe within the town walls. In 1845, the property was pulled down to make way for the Free Church Assembly Hall. Oratories were used for private devotions, a practice no doubt frequently employed by Mary of Guise during the turbulent sixteenth century.

Black Turnpike

This imposing house was built in 1461, just up the hill from the Tron church. Mary, Queen of Scots was brought here in 1567, after she had been captured at Carberry Tower, and before being imprisoned in Loch Leven Castle, at which time Black Turnpike was the home of Provost Sir Simon Preston. In contrast to the magnificent house, the ugly guardhouse of the City Guard, straddled across the High Street opposite, annoyingly interrupting the flow of traffic. The removal of the latter was welcomed, but the destruction of Black Turnpike, in 1788, to make way for Hunter Square, caused consternation among Edinburgh citizens.

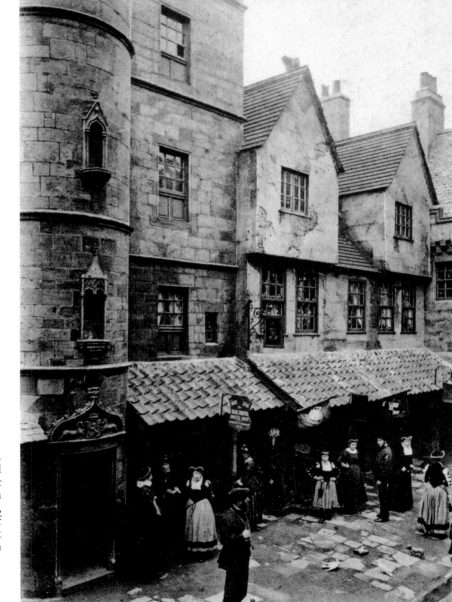

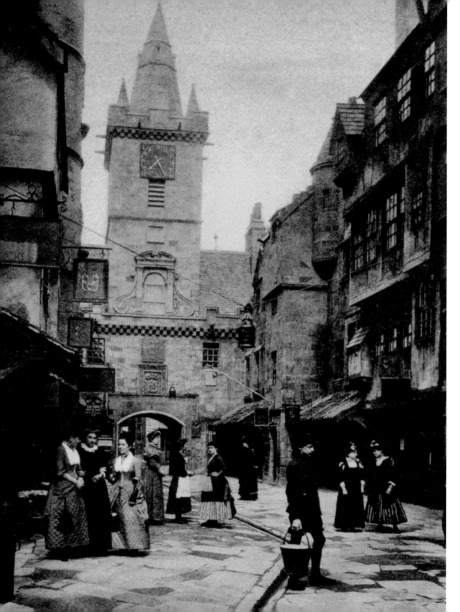

The Nether Bow Port

There were six ports, or gates, through which to enter Edinburgh after Flodden Wall was completed – West Port in Grassmarket, Bristo Port near Greyfriars, Kirk o' Field Port, Cowgate Port (eastern entrance to Grassmarket), St Andrews Port (exit to Leith) and Netherbow Port, which had existed from the fourteenth century, marking the boundaries of the ancient burghs of Canongate and Edinburgh. The picture shows the ornate, albeit impractical, structure after it had been rebuilt in 1606. The city was proud of it; a fact that was exploited by the Scottish Government, in 1736, when they threatened to demolish Netherbow Port as punishment for the Poteous Riots. It lasted another thirty years, but created an unacceptable bottleneck in the high street, and was demolished in 1764. The clock was retained and can be seen on the Dean Gallery.

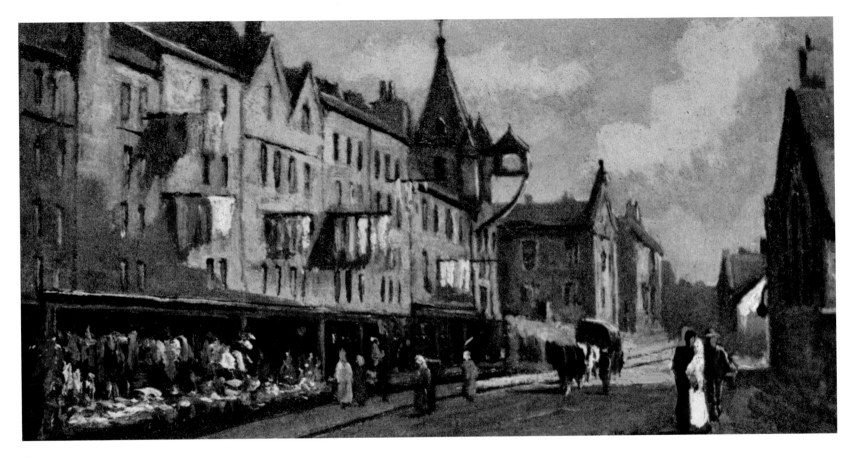

Canongate

This was a separate burgh from Edinburgh between its foundation in 1128 and integration into the city in 1856, and did not have the protection of the town walls. Holyrood Abbey was used as the parish church until the Reformation, after which Canongate Kirk was built in 1691 with funds donated by a local merchant. Many aristocrats lived in Canongate in the eighteenth century, but the attraction of the New Town reduced their numbers, which began a decline in the burgh's fortunes, although the many local breweries kept the life blood flowing. By the early twentieth century, many dwellings had become slums and, in both the 1930s and 1950s, the town council undertook major restoration and rebuilding work. None of the sixteenth-century houses remain. Another phase of change happened recently, when the modern Scottish Parliament building – which incorporated seventeenth-century Queensberry House – was built at the foot of Canongate, breathing new life into the ancient burgh.

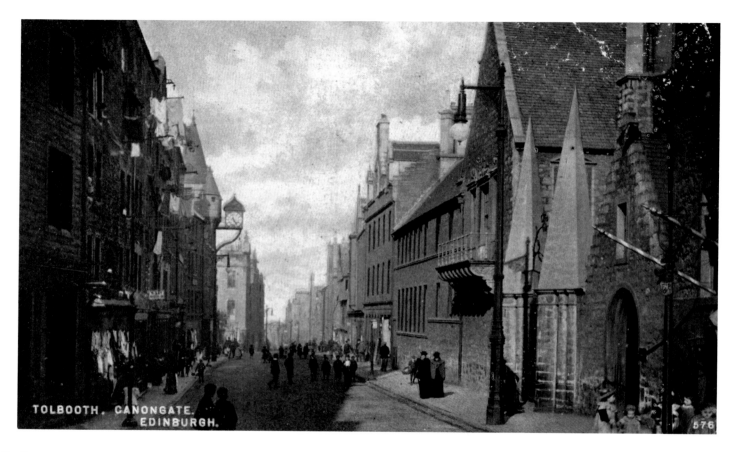

TOLBOOTH. CANONGATE.
EDINBURGH.

576

Tolbooth, Canongate

The original Tolbooth, dating from 1591, was altered and restored in 1879 to the prominent building seen today, which is used for The People's Story Museum. In 1797, the Magdalene Asylum for women was opened next door to the Tolbooth. The original function was to rehabilitate female prisoners, but the emphasis shifted to that of a refuge for prostitutes who wished to redeem themselves. 'Treatment' was brutal, and consisted of humiliation and abuse until the spirit was broken. The unenlightened attitude of the times is a welcomed loss. During later alterations to the establishment, a sealed bottle was buried with the foundation stone, containing 'various papers relating to the rise, progress and present state of the asylum'.

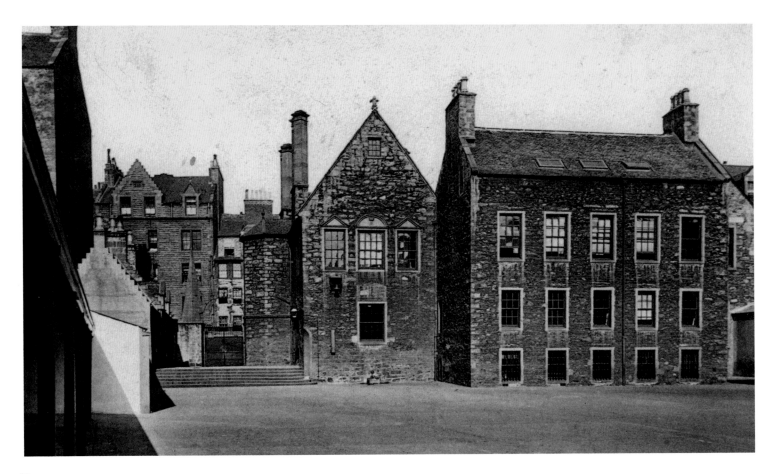

Moray House
This mansion belonged to the Moray family for 200 years, during which time they are thought to have offered accommodation to Oliver Cromwell, when Holyrood Palace had been damaged by fire. Behind the house were splendid gardens and orchards, which were the forerunners of Scotland's Garden Scheme being opened to the public. However, the greenery has been replaced by tarmac Moray House School of Education's car park, part of Edinburgh University's Faculty of Education.

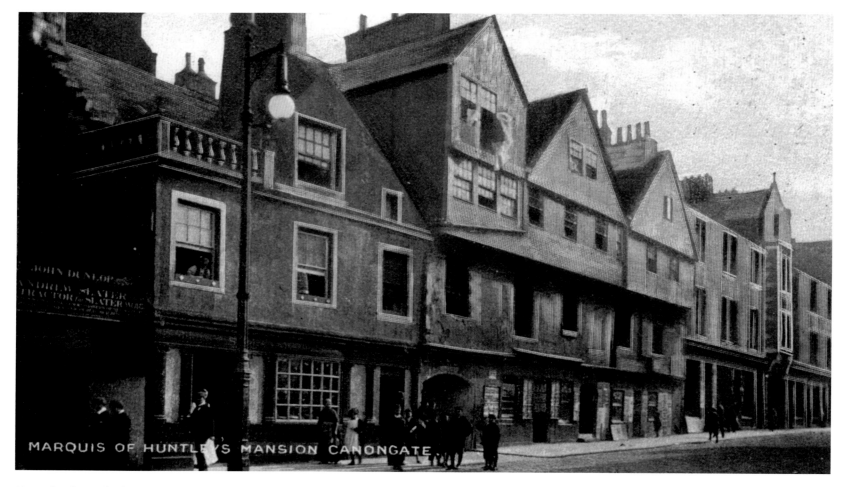

MARQUIS OF HUNTLEY'S MANSION CANONGATE

Marquis of Huntley's House

The name of this house is somewhat misleading, because the 1st Marquis only lived here for a short time in the mid-seventeenth century. It was built on the site of three early sixteenth-century thatched cottages, and extended, in a piecemeal fashion, to incorporate property in Bakehouse Close. In 1908, the *Scotsman* reported that demolition of Huntley House had been proposed, but, in 1927, it was saved and made into a museum. Artefacts on show include the original plans for New Town, the dog collar of Greyfriars Bobby and a sedan chair.

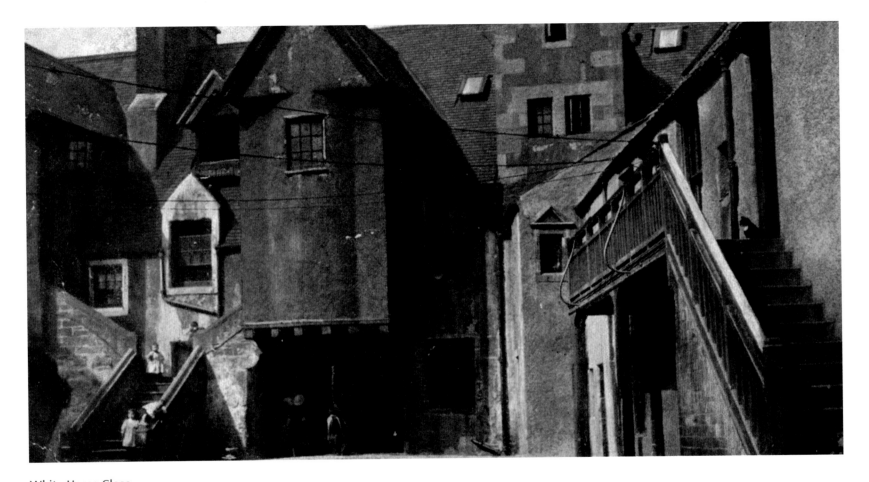

White Horse Close

This quote from the *Newcastle Courant*, in 1712, evokes the period when it was a stagecoach terminus. 'Edinburgh, Berwick, Newcastle Durham and London Stage-coach begins on Monday 13 October 1712. All that desire to pass from Edinro' to London, or any place on that road, let them repair to John Baillie's, at the Coach and Horses at the head of Canongate, every Saturday, or at Black Swan in Holborn, every other Monday, at both of which places they may be received in a stage-coach which performs the whole journey in thirteen days, without any stoppage (if God permit), having eighty able horses to perform the whole stage. Each passenger paying £4 10s for the whole journey allowing each 20 lbs weight, and all above to pay 6d per lb. The coach sets off at 6 in the morning.'

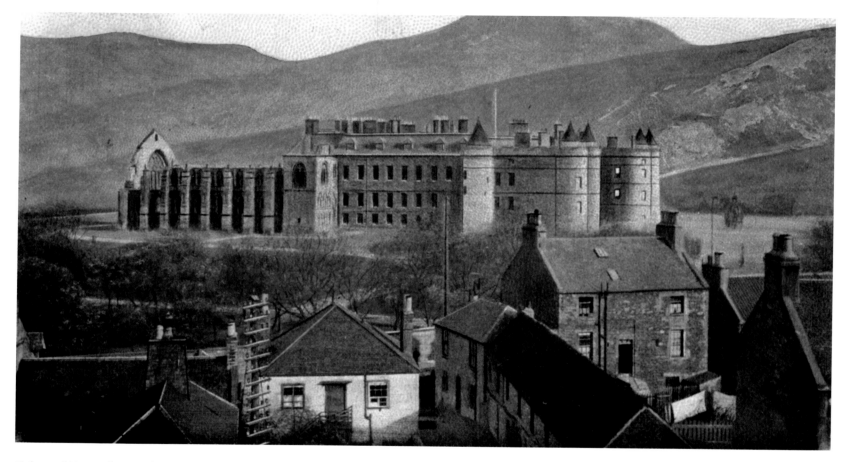

Holyrood House from Calton Hill

The abbey at Holyrood provided guest accommodation, which was used by royalty as an alternative to the castle, but it was James IV who, in 1503, decided to have a proper palace built next to the abbey. During the next 100 years, the palace saw a lot of blood and tears, most famously the murder of David Rizzio, confidante to Mary, Queen of Scots, but, in 1603, the Union of the Crowns resulted in James IV leaving Edinburgh for London. Holyrood was unoccupied until Charles I visited in 1633, and made considerable improvements. In 1650, Cromwell's army used it as their barracks, and accidentally caused a major fire. The damage was patched up, but, in 1670, significant rebuilding was ordered by Charles II. Falling into neglect again, in 1822 it was restored by George IV. It was Queen Victoria though, who chose to use it as a royal residence once again, and started the annual garden parties.

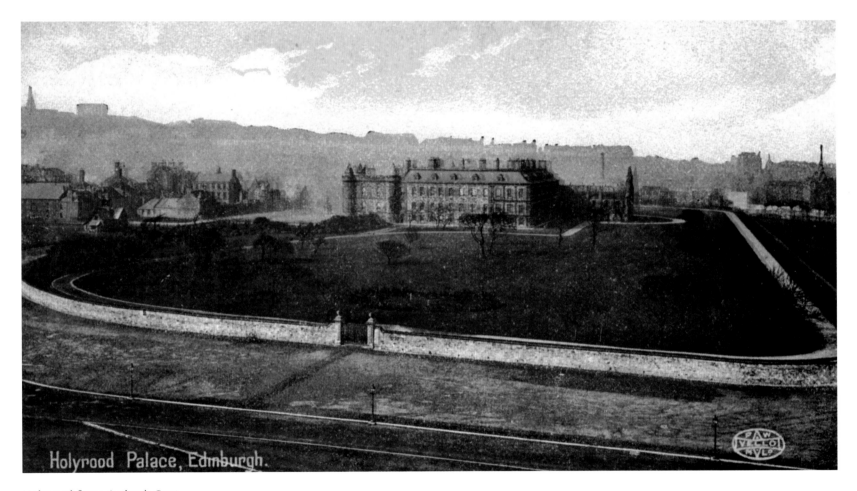

Holyrood Palace, Edinburgh.

Holyrood from Arthur's Seat

The skeleton of Holyrood abbey encloses so much of Edinburgh's history and aristocracy, but is overshadowed by its younger neighbour, the Palace of Holyrood House, which is built on the site of the cloister precinct. The remains of David II, James II and his queen, Mary of Gueldres, James V and Lord Darnley all rest within the royal vault. The building was completed in 1176 (the eastern doorway from this survives today) and, until Canongate Kirk was opened in 1689, the burgh congregation used the nave as their place of worship. The medieval nave has been open to the elements since 1768.

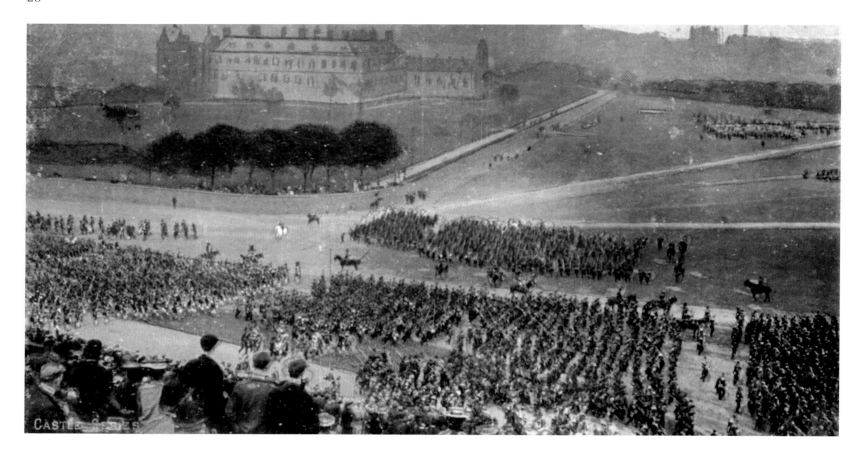

Royal Volunteer Review

The Volunteer Movement (1859–1908) was formed to protect the homeland, while the regular army were fighting for the British Empire, against the perceived threat from France. There was great enthusiasm for the movement in Scotland, particularly in the far north and, at the 1860 review in Holyrood Park, 40,000 spectators watched in the pouring rain as Queen Victoria inspected the parade. King Edward VII led the review in 1905, which was also attended by the newly formed Motor Volunteer Corps, who offered four-wheeled support to the generals and their staff, who were used to four-legged transport.

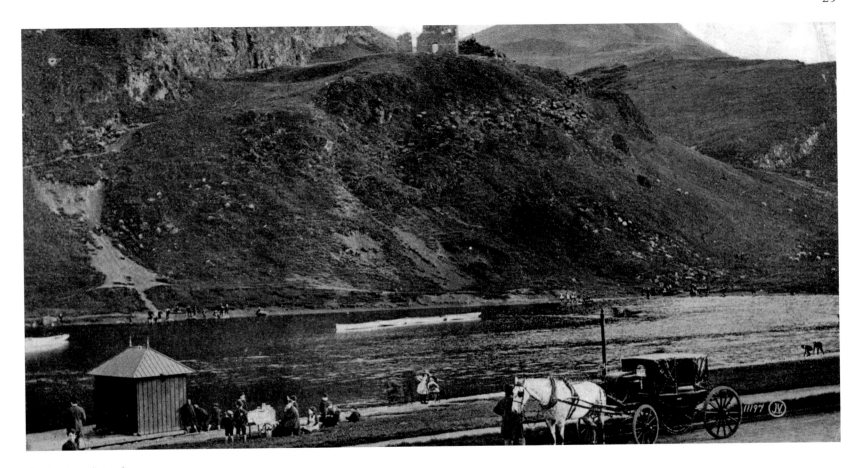

St Margaret's Loch
In 1541, James V was responsible for creating a royal park around the Palace of Holyrood by ordering a stone wall to enclose Arthur's Seat, Salisbury Crags and Duddingston Crags. This 640-acre park has proved to be a beneficial legacy to the citizens of Edinburgh as much as to royalty. Queen Victoria was fond of staying at Holyrood, and Prince Albert continued the tradition of royal care of the park by creating the shallow boating pond, known as St Margaret's Loch, in the boggy hollow at the foot of Whinny Hill.

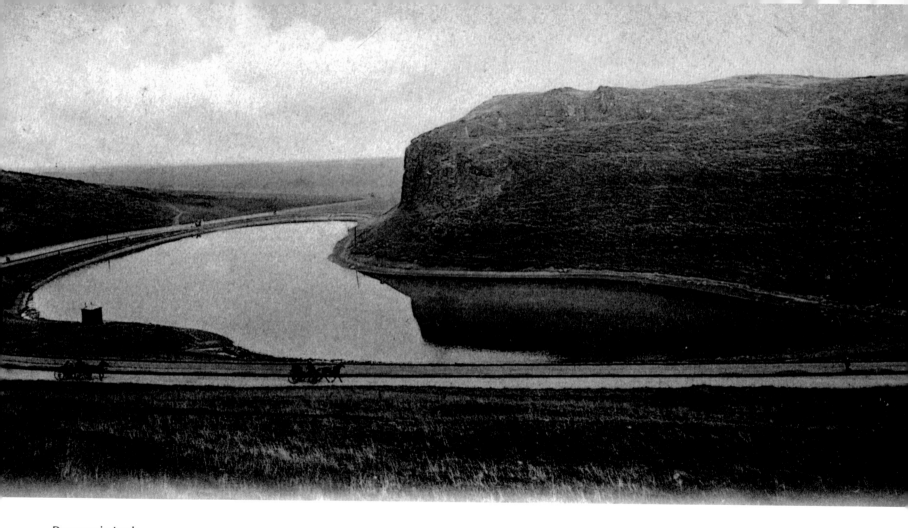

Dunsappie Loch
This was another feature formed artificially in 1844, the same year that Queen's Drive was made, which were both inspired by Prince Albert. Since this picture was taken, the greenery has matured and wildfowl are abundant on the water.

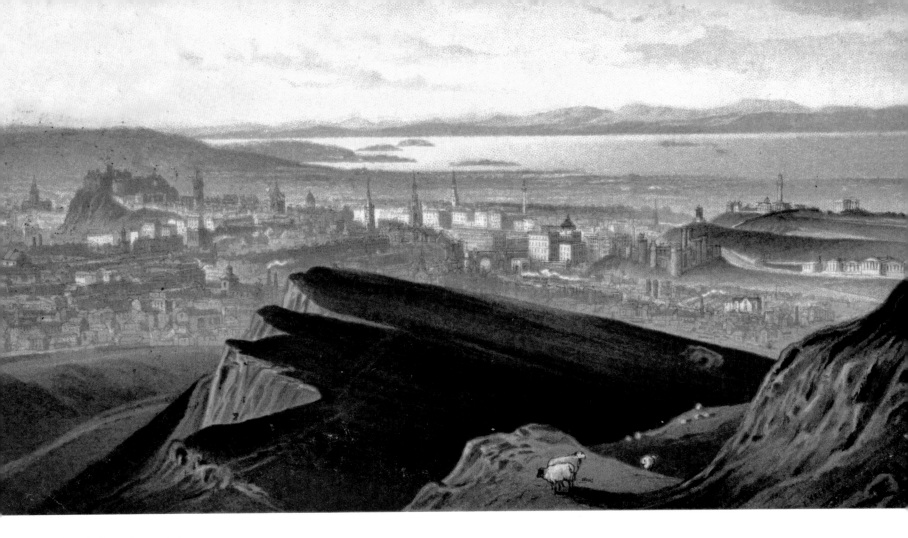

Edinburgh from Arthur's Seat
The slopes of Salisbury Crags and Arthur's Seat were used for grazing sheep right up until 1977.

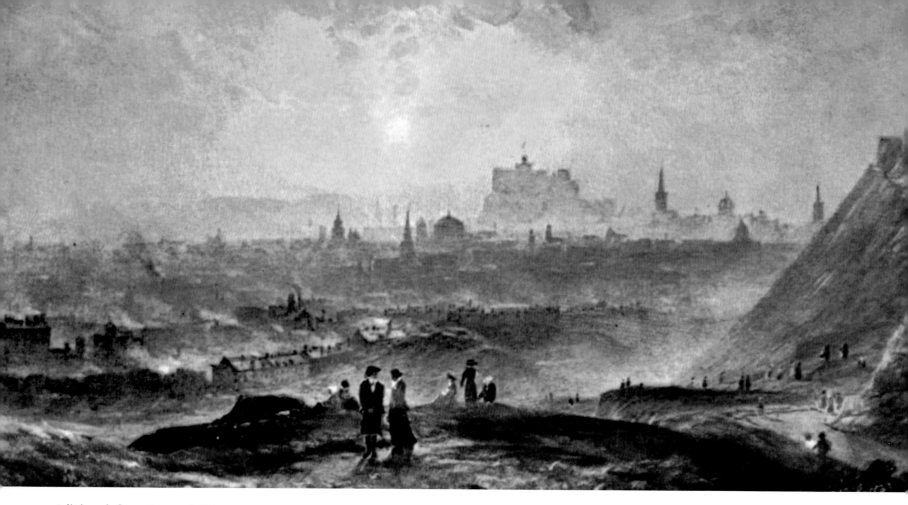

Edinburgh from Samson's Ribs
This postcard was sent in 1906, and the advertising caption read as follows: 'The grey metropolis of the North stands absolutely unrivalled as the most picturesque and beautifully situated city in the United Kingdom. Viewed from Samson's Ribs – a curious basaltic rock formation on the south east side – the whole city stretches out in a beautiful panorama, with the stately pile of Edinburgh Castle standing prominent above its surroundings.'

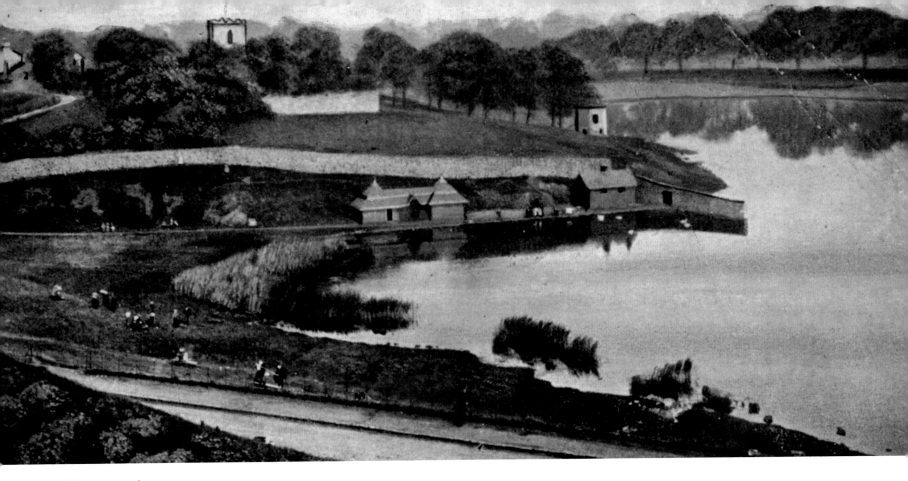

Duddingston Loch

While the Nor' Loch was very popular with skaters, Duddingston Loch was the location of the first skating club in the world, founded in 1742. The fashion is epitomised by Sir Henry Raeburn's painting of *The Skating Minister*, a portrait of Revd Walker, minister of Canongate Kirk and a member of the club. To become a member, applicants were required to pass a test consisting of completing a circle on each foot, then jumping over one, then two, and finally three hats perched on top of each other. In 1761, the Curling Club was started, becoming a society in 1795, with their own octagonal curling house. Remarkably, in 1924, there was a proposal to drain the loch and pipe the spring water into the city's supply.

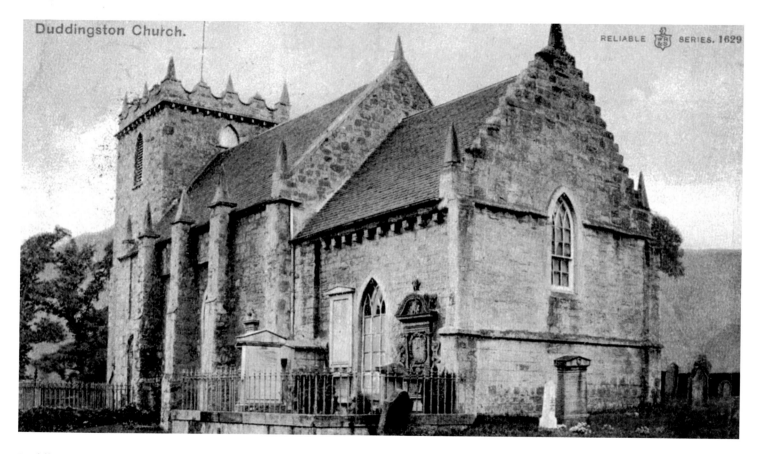

Duddingston Church.

RELIABLE SERIES. 1629

Duddingston Church

The building of today is built around a twelfth-century two-cell church, and is one of the oldest still in use. The gatehouse however, was not put up until 1824 and was required as a watchtower during the dark era of body-snatching in Edinburgh. The city was at the forefront of medicine, but cadavers required for research were in short supply in the early nineteenth century and one doctor in particular – the notorious Robert Knox – was willing to pay for recently deceased, exhumed bodies. The issue came to a head with the famous story of William Burke and William Hare.

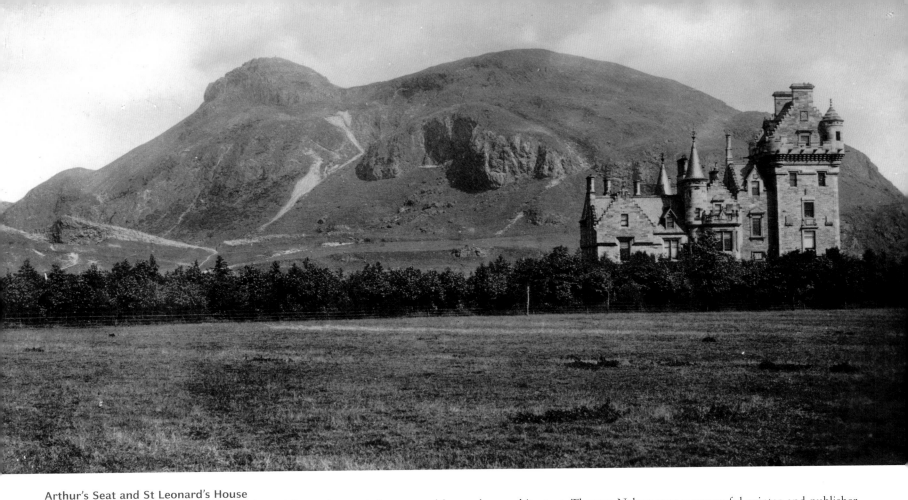

Arthur's Seat and St Leonard's House
Today, it is difficult to see the splendid baronial mansion, as it is swamped by modern architecture. Thomas Nelson was a successful printer and publisher, whose Parkside Works were situated where the Scottish Widows building now sits. In 1869, he built St Leonards House, while his brother owned the adjacent estate of Salisbury Green. All was subsequently sold to Sir Donald Pollock, who gifted the land to Edinburgh University. The house was used to accommodate female students, and named Pollock Halls, but since the modern halls were erected in the 1960s, administrative staff have the pleasure of working in it.

George Square, from *Old and New Edinburgh*
James Brown, a builder, had erected new houses (Brown Square) that were popular with wealthier citizens who wished to leave the congested High Street. In 1766, he saw the opportunity to capitalise on his success by purchasing the 24-acre Ross estate, just beyond Bristo Port. The result was the formation of George Square, a central garden surrounded by Georgian terraced townhouses, which quickly became very fashionable, and luminaries such as Walter Scott, Jane Carlyle and Henry Dundas took up residence there. However, it was soon eclipsed by the New Town. 100 years later, George Watsons Ladies College was added on the north side and, shortly after, Edinburgh University used it as accommodation. In the 1960s, George Square underwent major, and controversial (some say scandalous), redevelopment. It now has an array of modern university blocks, both high and low, overwhelming the one complete side of original houses, which are now Category A listed.

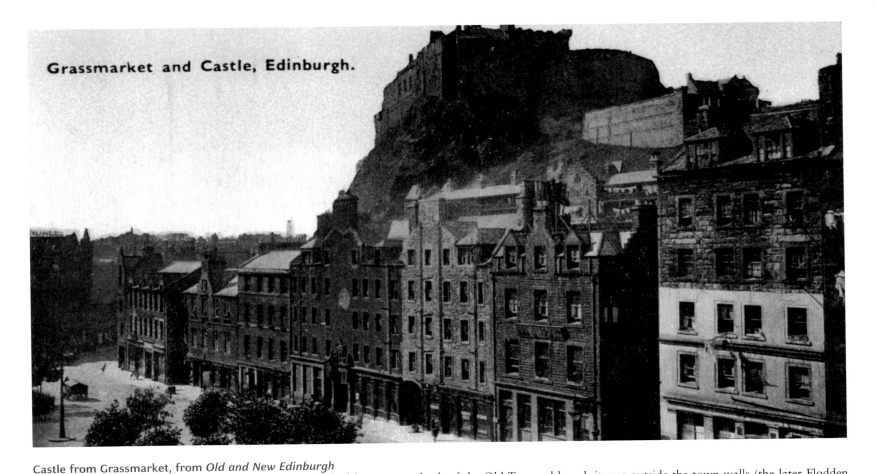

Grassmarket and Castle, Edinburgh.

Castle from Grassmarket, from *Old and New Edinburgh*

By 1500, this area, below the west face of Castle Rock, had become a suburb of the Old Town, although it was outside the town walls (the later Flodden Wall did include it, and entry was through West Port). West Bow, a narrow, steep, winding lane, led from Grassmarket up to Lawnmarket in Old Town. Farm produce and livestock came from the surrounding countryside, through Cowgate, to the corn, horse and cattle markets that continued until the early 1900s. The Grassmarket was always a colourful and lively place, but also had a darker history as executions took place here, most notably the Covenanters. Prisoners who had spent a wretched time in the Old Tolbooth were also brought down West Bow to meet their end here. It was customary to display the severed heads on spikes at the West Port. Contemporary Grassmarket is vibrant, home to interesting shops, cafés and restaurants, but has acknowledged its gruesome past by incorporating a gibbet shaped stone into the paving, near to the Covenanters Memorial.

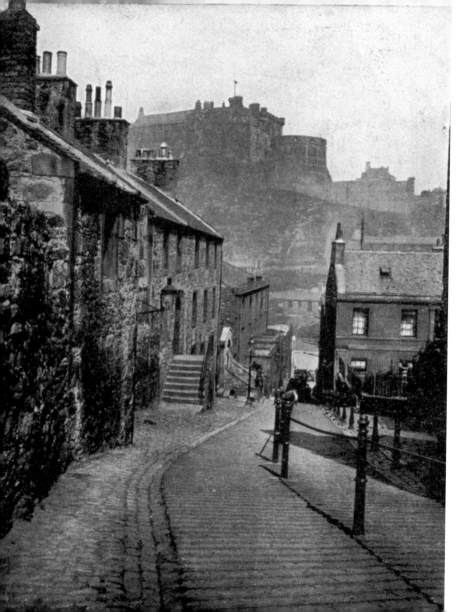

Castle from the Vennel

This old footpath from Lauriston Gardens follows the line of Flodden Wall, a stretch of which is still intact here. At the foot of the steps, where it enters the north facing side of Grassmarket, most of the buildings date from the nineteenth and twentieth centuries. Many of the houses on this side had become dilapidated, unsafe and unsavoury by the mid-nineteenth century, necessitating demolition and rebuilding. One of these to disappear was Tanner's Close, in which was the sleazy boarding house run by William Burke and his wife. He had come from Ireland to work on construction of the Union Canal, and met up with another Irishman, William Hare, who was lodging there. The notorious deeds began when a visitor died in the house, and they discovered that a Dr Robert Knox was willing to pay for freshly deceased bodies for anatomical research, and so began their murderous money-making venture. Burke was hanged in 1829, and his body given over for dissection.

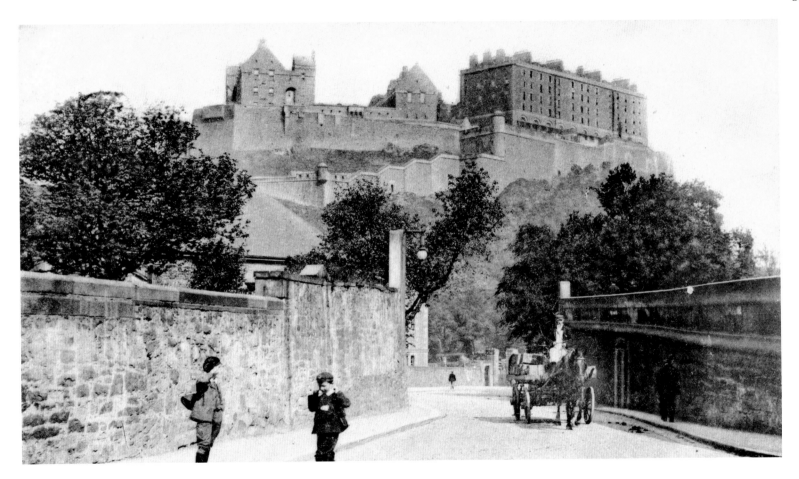

Castle from Lothian Road
King's Stables Road was cut through the old royal gardens and orchards, on the south side of Nor' Loch, to create a road into Grassmarket. Cattle markets were held here following a livestock ban within the town walls, and continued until 1843, when the purpose-built cattle market opened in Lauriston Place. When Johnstone Terrace was created in 1827, the King's Bridge, adorned by high obelisks at both sides, was constructed to cross this road.

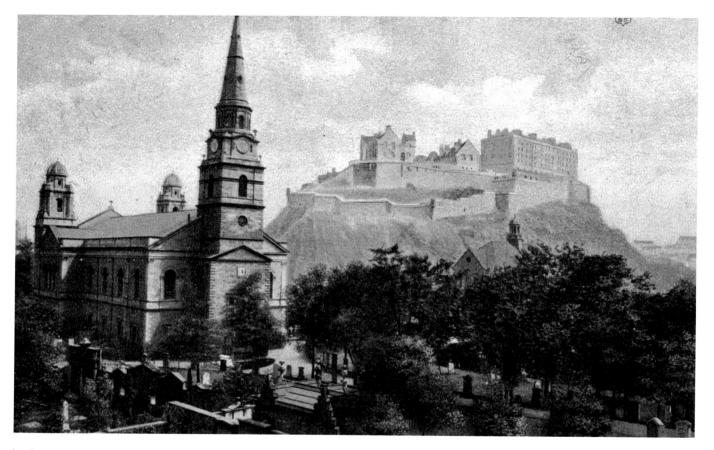

St Cuthbert's Church

The church standing today dates from 1892, and is the seventh ecclesiastic building on this site, the earliest records dating from 1127. One minister, of the many who served here throughout the centuries, was the Very Revd Dr James MacGregor, who was in service for thirty-eight years during the late Victorian era. He was physically tiny, necessitating a platform within the pulpit. What he lacked in stature, however, was more than made up for by the religious fervour with which he delivered his sermons, to regular congregations of 2,000 souls.

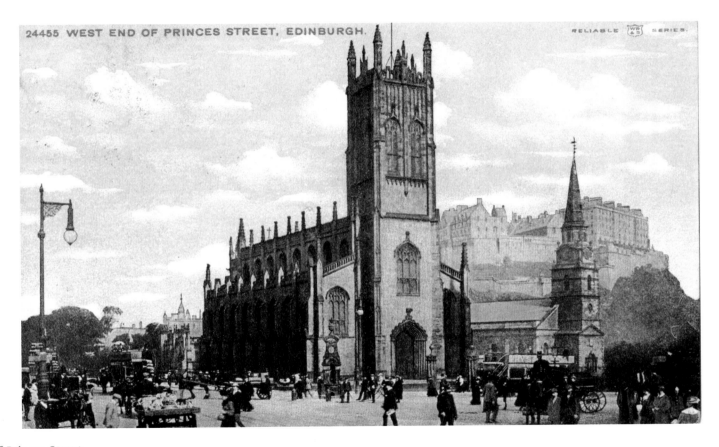

24455 WEST END OF PRINCES STREET, EDINBURGH. RELIABLE SERIES.

West End of Princes Street

This 1905 picture was taken exactly 100 years after the last house on Princes Street was completed. James Craig, who won the competition for the layout of Edinburgh's New Town, visualised Princes Street as purely residential, but the commercial potential of the property was quickly realised. The department store on the corner started as Maules, was then taken over by Binns, and is now owned by Frasers. A water fountain, primarily for horses, sat in the centre of the junction. The Sinclair fountain, erected in 1859, was inscribed with these maxims; 'Drink and be thankful; Water is not for man alone; A blessing on the giver.' In 1926, it was removed when it became a hazard to motor traffic, but the carved stones have recently be placed on the cycleway near the Water of Leith in Bonnington.

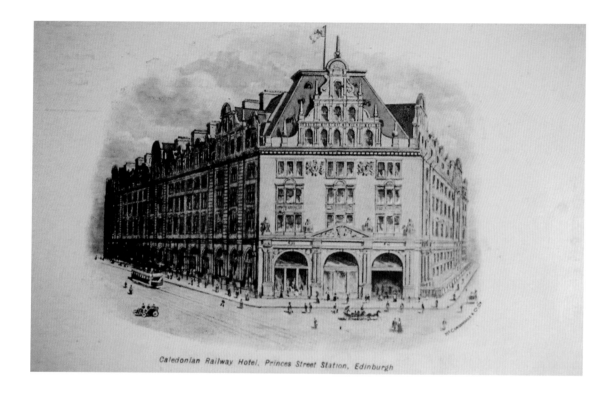

Caledonian Railway Hotel, Princes Street Station, Edinburgh

Caledonian Hotel

In 1869, the mansion and gardens of Kirkbraehead were swept away to make way for the Caledonian Railway, and associated hotel, rivals of the North British equivalent at the east end of Princes Street. Lothian Road was purportedly built in one day by a vast workforce of unemployed labourers under the direction of Sir John Clerk of Penicuik. St George's Free church, only twenty-five years old at this point, was also a casualty, but was reconstructed in Deanhaugh Street, Stockbridge, where it survived until 1980 (the attractive clock tower still adorns the shop underneath). The bright red Dumfriesshire stone used to build The Caledonian Hotel did not meet with universal approval, as it was considered unsympathetic to the local architecture at the time.

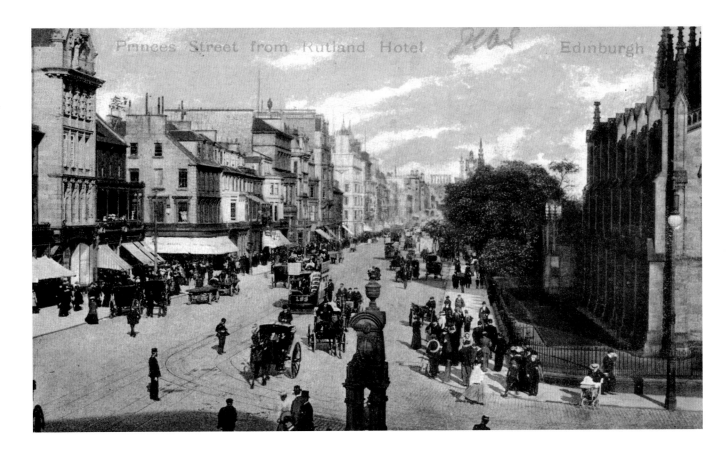

Princes Street from Rutland Hotel, 1817
St John's church was built at the west end of Princes Street. The following year, a bad storm blew down the open lantern in the tower, an event recorded by Walter Scott: 'I had more than an anxious thought about you all during the gale of wind. The Gothic pinnacles were blown from the top of Bishop Sandford's episcopal chapel at the end of Princes Street, and broke through the roof and flooring, doing great damage. This was sticking the horns of the mitre into the belly of the church. The Devil never so well deserved the title of Prince of Power of the Air, since he has blown down this handsome church and left the ugly mass of new buildings standing on the North Bridge.'

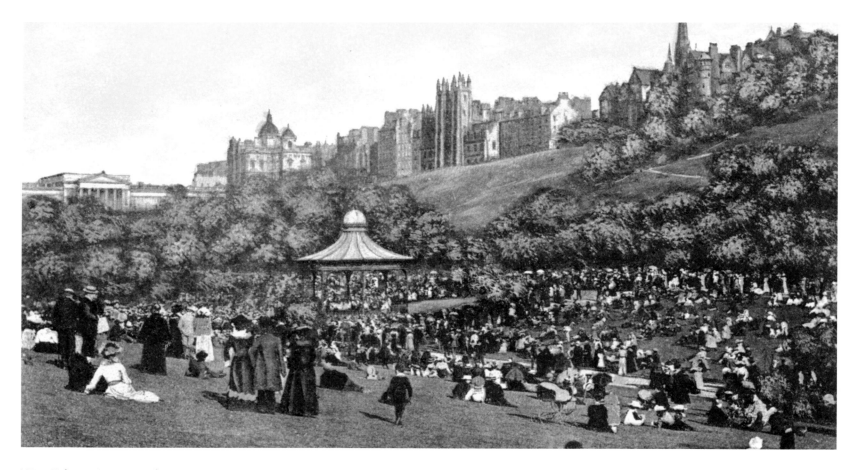

West Princes Street Gardens

The residents between Hanover Street and Hope Street were keen to prevent buildings being constructed between their houses and Castle Rock. The open space was no more than the dregs of the Nor' Loch, however, described by Lord Cockburn as 'A fetid and festering marsh, the receptacle for skinned horses, hanged dogs, frogs and worried cats'. They formed a committee that secured a lease of the land from the council, and began the improvements by laying a walkway along the southern edge, enclosed by railings. Trees, shrubs and flowers were planted and, by 1832, a full-time gardener was employed. The lease was extended to include the grassy slopes around the Castle Rock, although, around 1840, it was reported that a patch of turnips had been cultivated here. The gardens were initially private, although the public were allowed to stroll through for a fee.

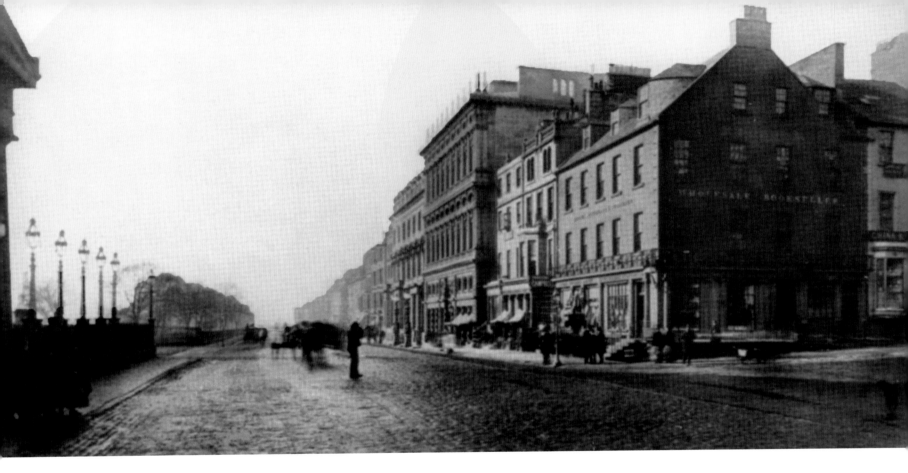

Princes Street

The original Princes Street consisted of a uniform line of three-storey houses, but, by the 1830s, the emphasis had moved towards commercial premises, initially on a small scale. Bookshops and silk mercers used the ground floors and basements, while the flats above were rented out. Ladies could be seen arriving, by sedan chair, to inspect the new wares. Larger businesses, such as hotels and insurance companies, began to appear, some of which altered or extended the property. The grand head office building of The Life Association of Scotland was lauded when it opened in 1858 (tallest in the picture), and whose demolition, in the 1960s, was fiercely opposed. During the late Victorian era, the trend of enclosing public building in metal railings diminished, and the Royal Institution (now Royal Scottish Academy) was 'freed' in 1897. By 1820, the gas lamps shown had replaced those of oil.

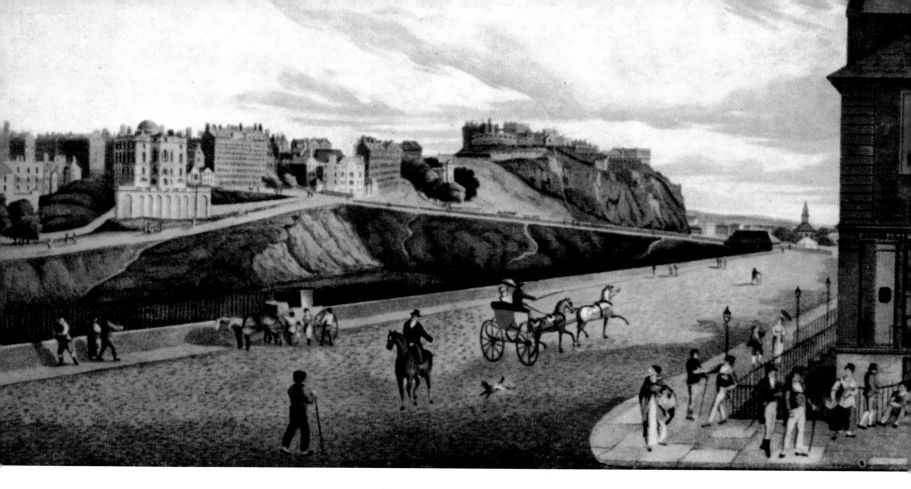

Old Town from Princes Street Looking West
Coloured aquatint from 1814, by J. Clarke, after A. Kay. The countryside, on which James Craig's New Town was laid out, stretched from Multrees Hill in the east, along the ridge of Bearfords Park, roughly along the line of a track known as the Lang Gait. It was suggested that the vast amount of earth being moved should be placed in the Nor' Loch valley, creating a passage crossing from Old Town, which of course evolved into the Mound. At the top of this, the flamboyant headquarters of Bank of Scotland, which had been built in 1801, sat at the edge of Old Town, looking down on the fast growing new one.

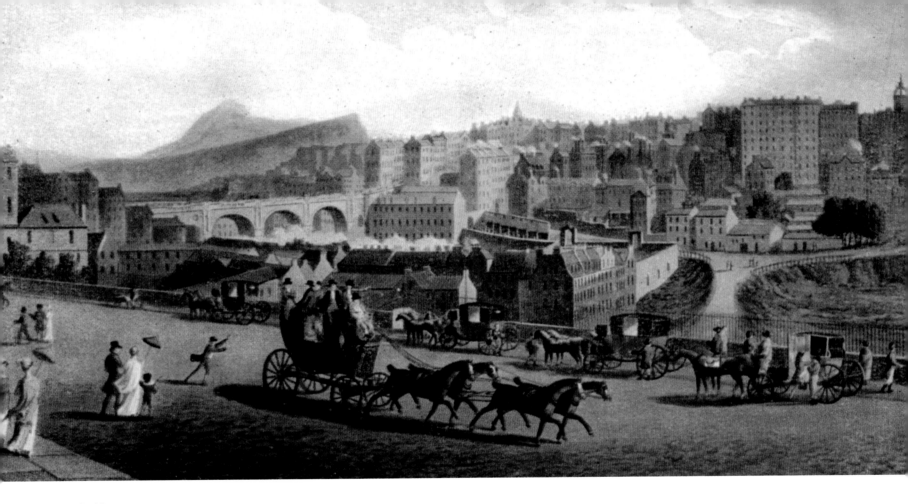

View of Old Town
Aquatint from 1812, by J. Clark, after A. Kay. In 1722, North Bridge was completed, providing the first crossing from Old Town over the Nor' Loch valley and the beginning of a new episode in the history of Edinburgh. Naturally, the citizens were very keen to come across to watch the progress, and one such enthusiast – a tartan seller from Lawnmarket – had the idea of creating a shortcut across the marshy valley with stepping stones. This was nicknamed Geordie Boyd's mud bridge, and is said to have inspired the ultimate idea for the Mound.

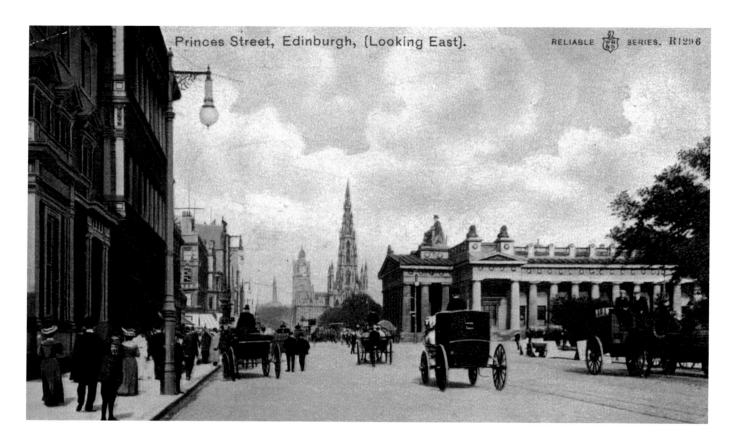

Princes Street, Edinburgh, (Looking East). RELIABLE SERIES. R1296

Princes Street, Looking East

In the early days of New Town, the eastern end of Princes Street was closed off by Shakespeare Square, so Calton Hill was reached from Leith Street. In 1815, the buildings, including the Theatre Royal, were cleared away to form Waterloo Place, Regent Road and Regent Bridge. This end of Princes Street was first to be built, and almost ended up with buildings on both sides of the road, thus depriving the new residents of their unique view. The case was ultimately settled in the House of Lords, and the landowner was only allowed to build his market below street level. In 1877, a flat roof was added, and the street level space on it used for travelling shows and exhibitions. The subterranean development is now called Princes Mall, although locals still refer to it as Waverley Market. The original roof garden has been replaced by a modern seating area.

OLD TOWN, EDINBURGH.

Copyright

Old Town and Bank of Scotland

In 1695, the Bank of Scotland was opened in modest premises in Old Bank Close, with £120,000 Scots, equivalent to £10,000 sterling. In 1745, when Charles Edward Stuart marched into Edinburgh with his Jacobite army, the bank closed up and took all documents and money to the castle for safekeeping. It became the first bank in Europe to issue paper currency, and paved the way for Edinburgh's reputation and success as a financial centre. The original premises were used for over 100 years, until the prominent head office was built in 1801. The design was criticised and altered by architect David Bryce in 1863 to the one seen now. In 1829, Old Bank Close was demolished to make way for George IV Bridge.

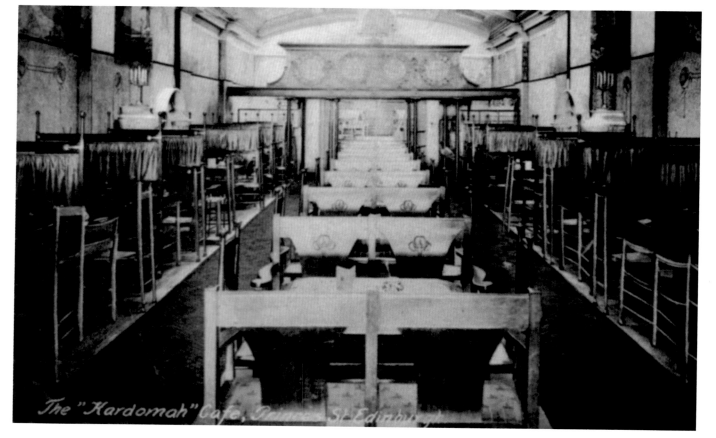

The "Kardomah" Cafe, Princes St Edinburgh

Kardomah Café, Nos 111–112 Princes Street, 1910
'You can drink the most delicious tea and coffee with dainty biscuits and cream for 3*d* a cup.' Poole's was one of the earliest coffee houses in Princes Street, mentioned in 1783 as the regular meeting place for soldiers and war veterans. The establishment went on to become a hotel.

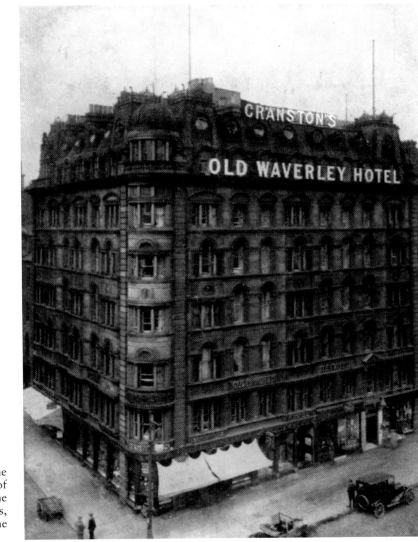

Old Waverley Hotel

Originally a temperance hotel, this building was extended in 1883 to become one of the highest in the street, having six storeys and two levels in the roof space, all reached by hydraulic lift. There is some ornate stonework on the outside walls between floors, notably busts of well-known Edinburgh citizens, but they are badly weathered. Between 1856 and 1921, the shop on the ground floor was occupied by Lennie, an optician's.

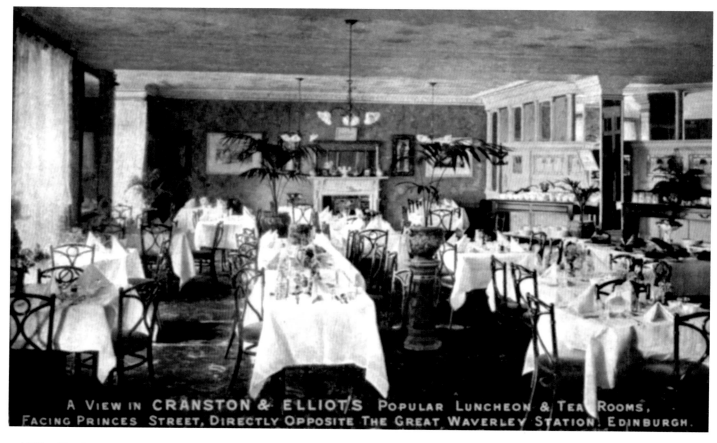

A VIEW IN CRANSTON & ELLIOT'S POPULAR LUNCHEON & TEA ROOMS, FACING PRINCES STREET, DIRECTLY OPPOSITE THE GREAT WAVERLEY STATION, EDINBURGH.

Cranston and Elliot Tea Room
This fashionable Princes Street store was opened after its predecessor, Rentons Drapery, burnt down in 1909. The items for sale ranged from silks, costumes and underclothing, to china, carpets and linens. The outlook from the tea room on the second floor, across the gardens to Old Town, was an attraction; their own advertising claimed they were: 'The best appointed and most comfortable luncheon and tea rooms out of London'.

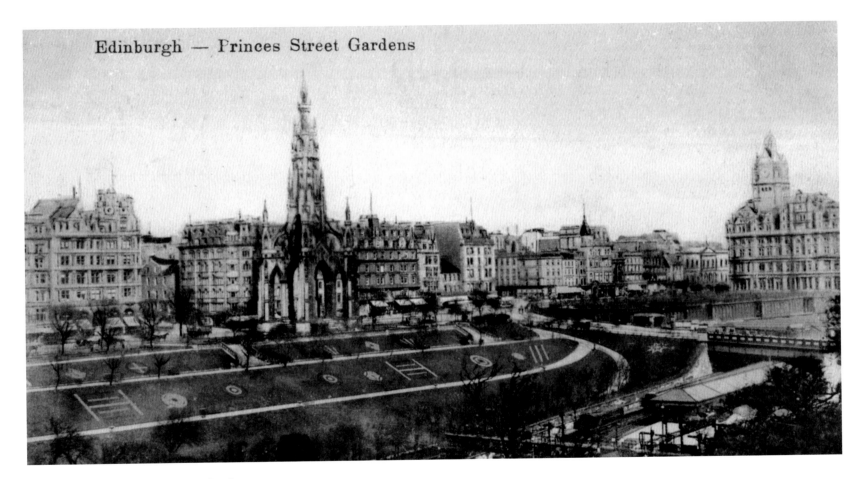

Edinburgh — Princes Street Gardens

Crocus Beds, East Princes Street Gardens
The city soon realised the importance of the open outlook from their new thoroughfare and, spurred on by improvement in the western gardens, plans were drawn up to outdo their neighbours and, in 1832, a full-time nurseryman was taken on. The formality of planting crocuses in linear beds has long gone, as they grow up randomly through the grass nowadays.

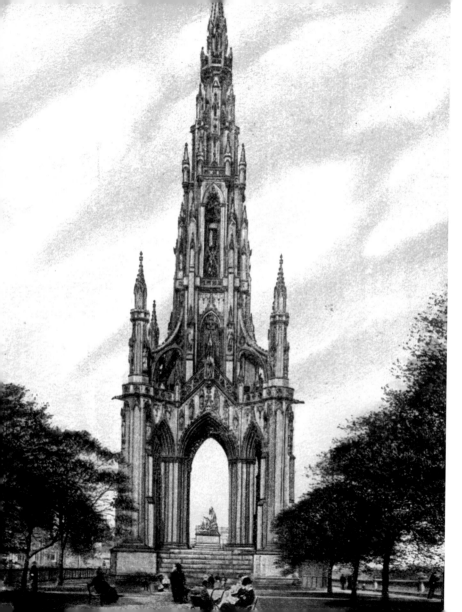

Scott Monument

The aforementioned development of the eastern grounds in Princes Street was soon to be embellished on a grand scale with the erection of the monument to Walter Scott, Edinburgh's greatly admired author. The Gothic design was chosen ahead of a giant obelisk, submitted by Playfair, for the opposite end of the street. George Meikle Kemp, the young, self-taught architect who won the design competition, unfortunately did not see the completed work. He fell into the Union Canal on a foggy night and drowned.

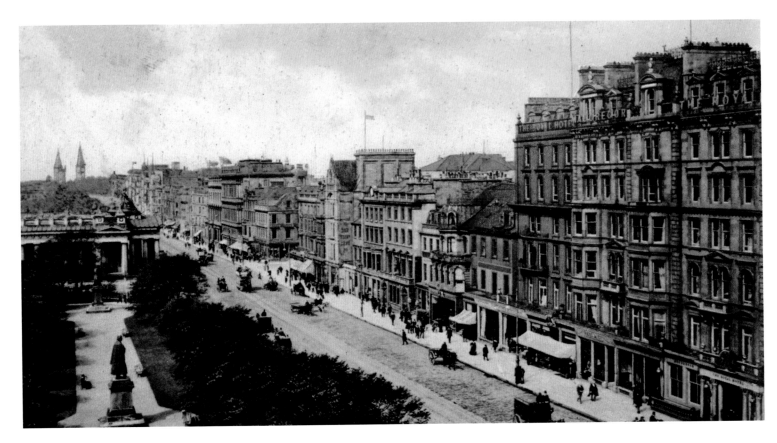

Princes Street Shops

When New Town first began to develop, not only was Princes Street purely residential, but provisions were purchased from the markets in the Old Town – Fishmarket Close, Fleshmarket Close, and the fruit and vegetable market below North Bridge. Robert Kirkwood's 1819 map shows a track named 'New road to markets', diagonally crossing the land that became East Princes Street garden. In 1866, the market was demolished when the railway company required more land, and gave over the ground that had been previously occupied by Canal Street station, from which the Edinburgh, Dundee and Perth line passed through a tunnel under Princes Street by Canal Street station, which became Waverley Market. By the time this picture was taken, Princes Street had become filled with shops, as it remains today.

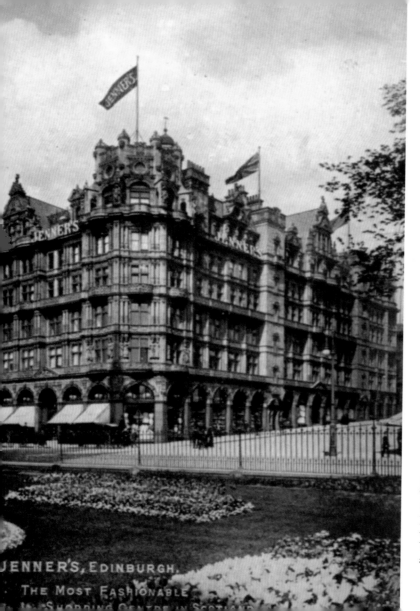

JENNER'S, EDINBURGH.
THE MOST FASHIONABLE
SHOPPING CENTRE IN SCOTLAND

Jenner's

The shop preceding this – Kennington and Jenner – was destroyed by fire in 1892. Charles Jenner employed the architect William Hamilton Beattie to design a grand, Renaissance-style department store. It was one of the largest in Britain and certainly thrilled the citizens of Edinburgh. It was known as the 'Harrods of The North'. Unusually for the time, the supportive role of women in the shop's success was acknowledged, with a series of carved female figures high up on the columns.

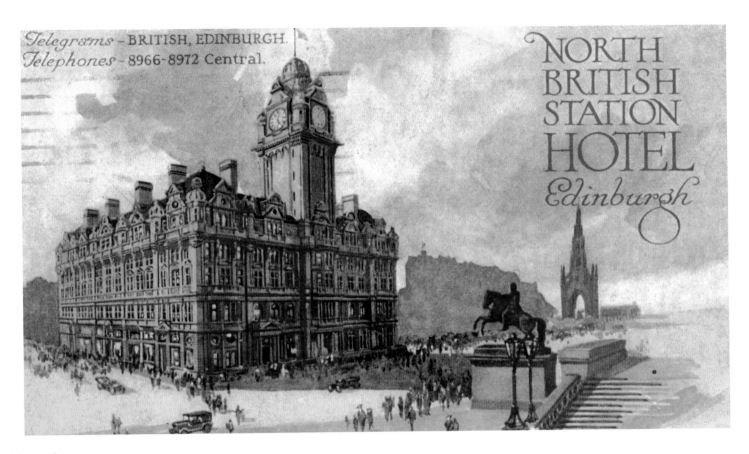

Telegrams – BRITISH, EDINBURGH.
Telephones – 8966-8972 Central.

NORTH
BRITISH
STATION
HOTEL
Edinburgh

North British Hotel

The open ground at the far east end of Princes Street was the subject of a complicated ownership issue, but ended up with a coach builder called John Hume. He built a row of five-storey tenements – St Anne Street – rising up from Canal Street in the valley to North Bridge, causing an unsightly 'book end' in the view. The Edinburgh citizens had already appreciated that the outlook across Nor' Loch valley to Old Town was spectacular, and a group of luminaries, including David Hume, philosopher and historian, were instrumental in a 1776 Act preventing building above street level on the south side. The North British Railway radically altered the corner of North Bridge and Princes Street in 1895, when they cleared all the buildings in order to build their large North British Hotel, which was designed by the same architect as Jenners.

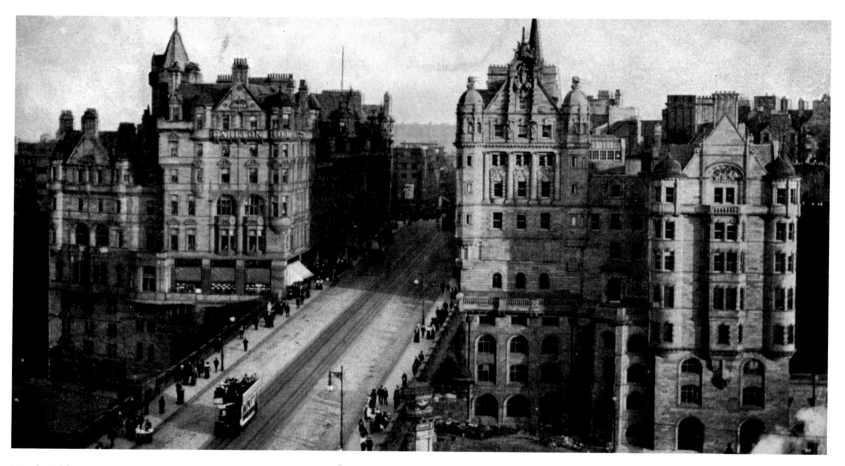

North Bridge

Lord Provost George Drummond had been agitating for some years in the mid-eighteenth century to have an access route to the north of Old Town, primarily to cross the Nor' Loch valley into the countryside. The foundation stone for the three arch North Bridge was laid in 1763 and, by 1769, pedestrians were able to cross it. Between these dates the Nor' Loch was drained and, in 1767, a Bill was presented to Parliament to extend the Burgh. Construction of such a large bridge was an amazing feat of civil engineering, though not all went well; part of it collapsed at one end and had to be rebuilt. A few years after completion it had to be widened due to the high volume of traffic. However, it proved to be the route to a new chapter of Edinburgh's history. Provost Drummond sadly died before it was finished in 1772.

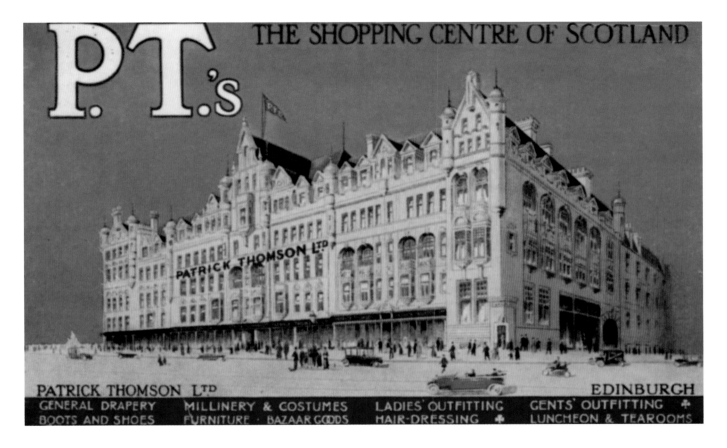

Patrick Thomson's

This large store started life as a small haberdashery shop called Thomson & Allson, situated on South Bridge and, in 1906, moved across the road to larger premises on North Bridge. The business flourished and, at its height, the store had sixty departments. It became known affectionately as PT's, and when House of Fraser (who took it over in 1952) renamed it Arnotts, in the 1970s, the locals were not amused. Whether the name change had anything to do with it will never be known, but twelve years later the department store closed down.

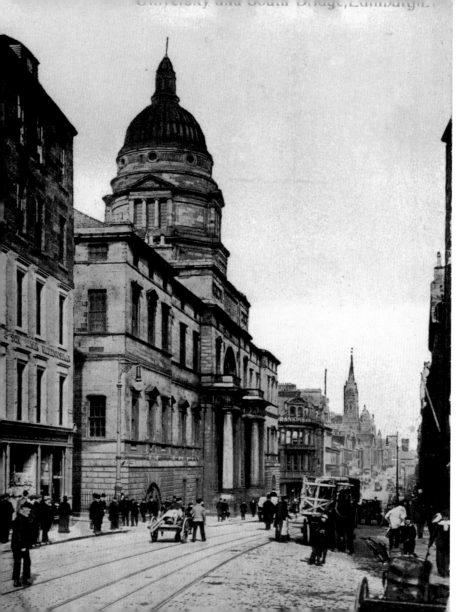

South Bridge and the University

Edinburgh has long been associated with learning. As early as 1582, James VI granted a charter to provide a college for teaching humanities and theology. These days were not long after the Reformation; one casualty of which was St Marys in the Field (or Kirk o' Field), the site on which the University Old Quad still stands. Teaching took place in the damaged ecclesiastical buildings until the early 1600s, when these were converted into the College of St James. In the spirit of the Age of Enlightenment, it was deemed necessary to build a new university, which was designed by Robert Adam and opened in 1789. There is a finial on the dome of a boy carrying the torch of knowledge and, at the time of writing (2014), the so-called 'golden boy of learning' is being re-coated with gold leaf. The reputation of Edinburgh University, however, remains untarnished.

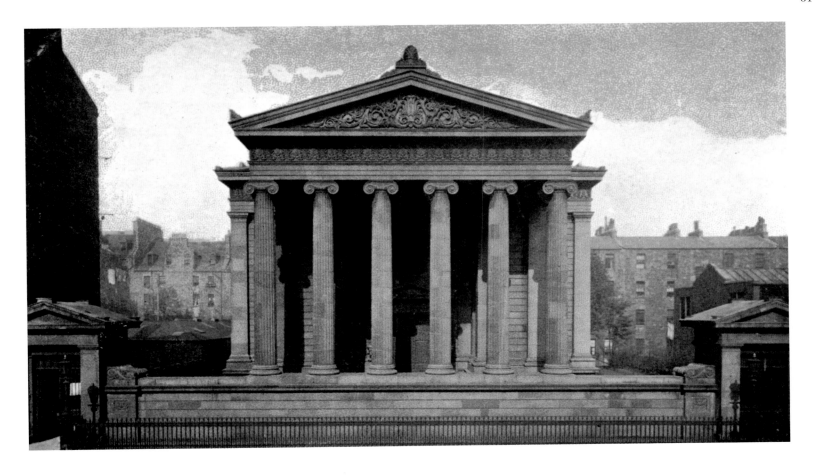

Surgeon's Hall
In medieval Edinburgh, surgeons were classified with barbers, an association the medical men didn't manage to change until 1722 when the first Chair of Anatomy was formed. Their first meeting rooms were in a tenement in Dickson's Close, before moving to Old Surgeon's Hall, in 1697, where they held annual public dissections. At the turn of the eighteenth century, more space was required, partly to accommodate the large collection of pathological specimens. They purchased the Royal Riding School in Nicholson Street, where the new Surgeon's Hall, designed by Playfair, was built.

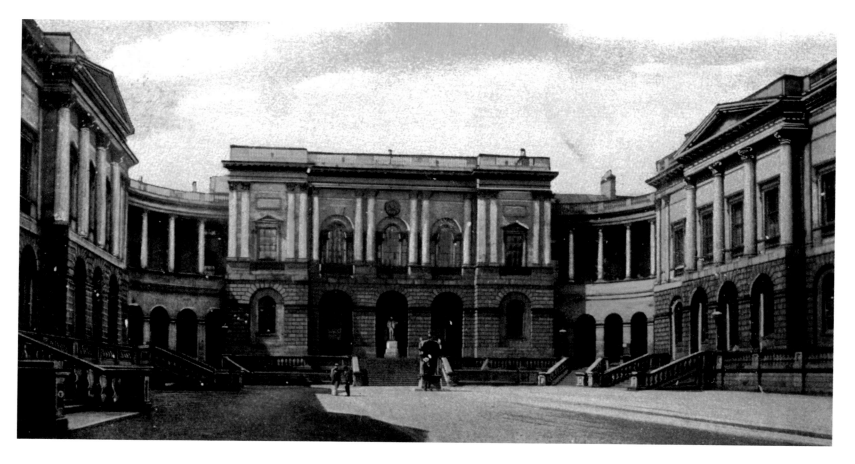

Brown Square
All traces of these houses have disappeared, the last ones being cleared in the 1960s for The Museum of Scotland. When they were erected, in 1764, the townhouses were considered very desirable because the builder, James Brown, created a new architectural style. He went on to develop George Square, which was the first expansion of the burgh outside Old Town. During the early nineteenth century, Brown Square was partly removed to create Chambers Street and George IV Bridge.

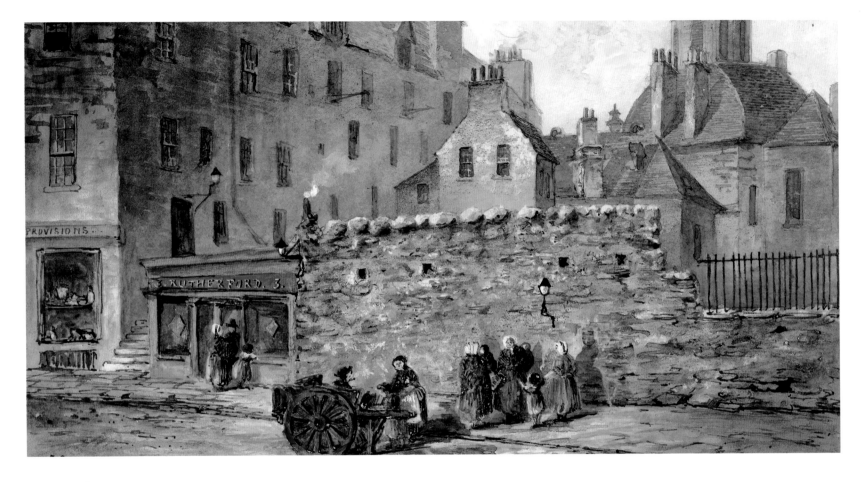

Drummond Street

This street lies on the southern edge of Flodden Wall, a portion of which – including a bastion – can still be seen at the eastern end, so was outside the old Burgh and wasn't built up until the late 1700s. However, the area just inside the wall was the medical quarter of old Edinburgh – the dome of the old Royal Infirmary can be seen in the picture – and Surgeon's Hall was nearby in Surgeon's Square. Blackfriars Monastery used to occupy this land, until it was wrecked by followers of John Knox during the Reformation in 1558, after which, the town's first high school was built on the site. In 1829, this establishment moved to Regent Terrace and, a few years later, the old high school building became the surgical hospital, attached to the Infirmary.

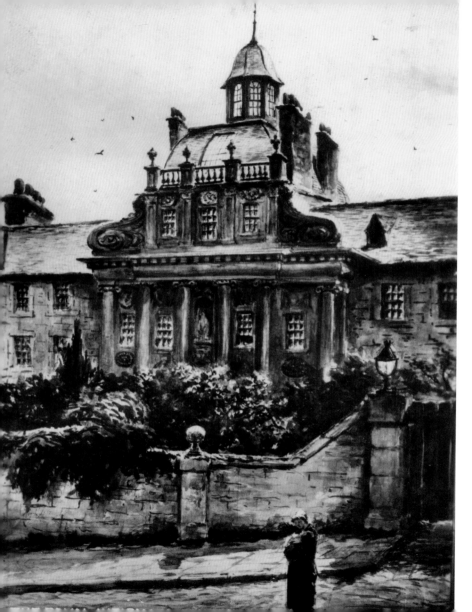

Old Royal Infirmary

By 1700, about 50,000 people were living cheek by jowl in the cramped, overpopulated Old Town. Their waste, as well as that of the pigs and other animals, must have made the streets and narrow closes unimaginably filthy, smelly and insanitary. Consequently, sickness was rife, especially among the poor. It was an impoverished and dark era after the Darien Disaster and subsequent union in 1707. Lord Provost Drummond saw the need for an establishment to care for the afflicted, and money was raised by public appeal for a house in Robertson's Close, off Cowgate, where thirty-five patients were treated without charge in the first year. Public support was such that, by 1738, sufficient money had been raised to build a hospital, capable of taking 1,700 patients in the appropriately named Infirmary Street. It was used until 1879, when the new Royal Infirmary opened in Lauriston Place.

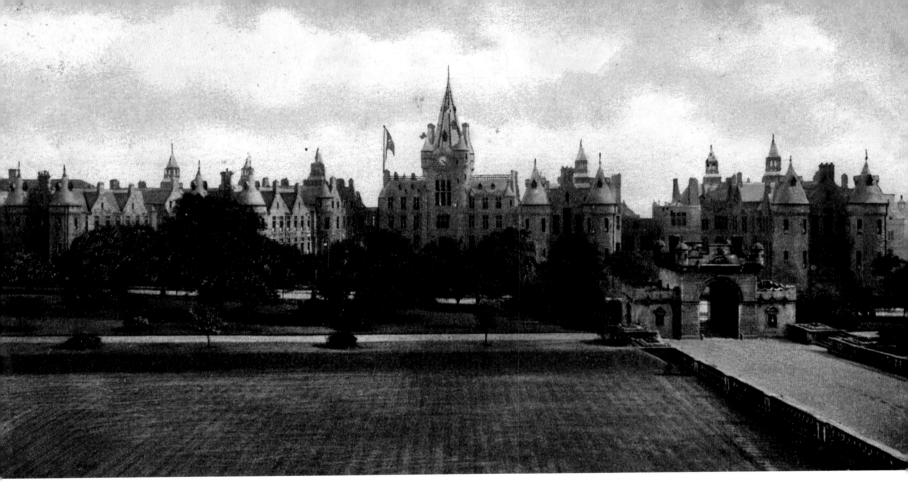

Royal Infirmary from the North
The huge hospital complex served Edinburgh between 1879 and 2002. The elevated location at the northern side of The Meadows, and parallel pavilions with balconies, were considered to be important factors for a healthier environment to minimise the spread of infection. It eventually closed in 2002, when the more modern Royal Infirmary was built at Little France, but the outer walls have been retained as frontages to a multi-use project called Quartermile.

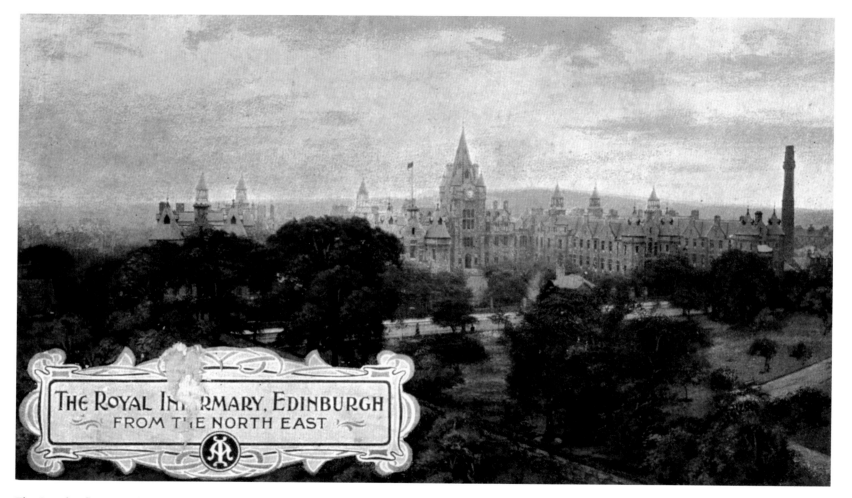

The Royal Infirmary of Edinburgh
Founded in 1728, in 1906 the hopsital recorded treating 11,216 indoor patients, 37,235 outdoor patients, with a average of 839 patients in the hospital on a daily basis. Inpatients cost the hosptial around £5 a day, which amounted to nearly £22,000 a year. Charitable contributions in the year 1906 reached £9,000, which resulted in the hopsital having to draw a large sum from the invested funds to meet the costs.

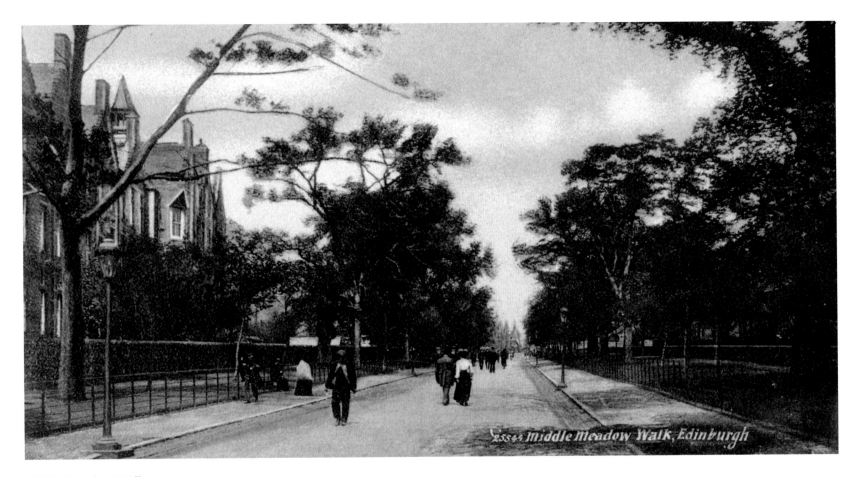

Middle Meadow Walk

The area known as The Meadows was once the Burgh Loch, filling the low land between Edinburgh and the wooded ridge of Burgh Muir. In 1598, the Society of Brewers was founded by James VI, and several breweries operated to the east of the loch. The water supply, which was cleaner than that from the Nor' Loch, was pumped out with the help of a windmill, but, by 1619, had markedly reduced the loch. In 1657, the town council drained it, apart from a watering hole for horses, and it remained this way until 1722, when Thomas Hope of Rankeillor purchased the land. This public spirited man decided to turn the marsh into an ornamental public park, during which period, the area was closed off. The town council requested that a temporary walkway could be constructed across the middle … and so began Middle Meadow Walk.

St Catharine's Convent

This opened in 1860 at the western end of Lauriston Gardens, a few years before the Royal Infirmary was built at the opposite end of the street. It is named after Mother Catharine McAuley, who founded The Sisters of Mercy in Ireland, to care for the destitute. Today, it is used as a support centre for the homeless and those in need. A small Dominican convent of the same name, devoted to St Catharine of Sienna, existed in the Scienne's area in the early sixteenth century, and was run by aristocratic ladies who were widowed after Flodden. It was burnt down during the Rough Wooing by Earl of Hertford's army in 1544, then completely destroyed during the Reformation.

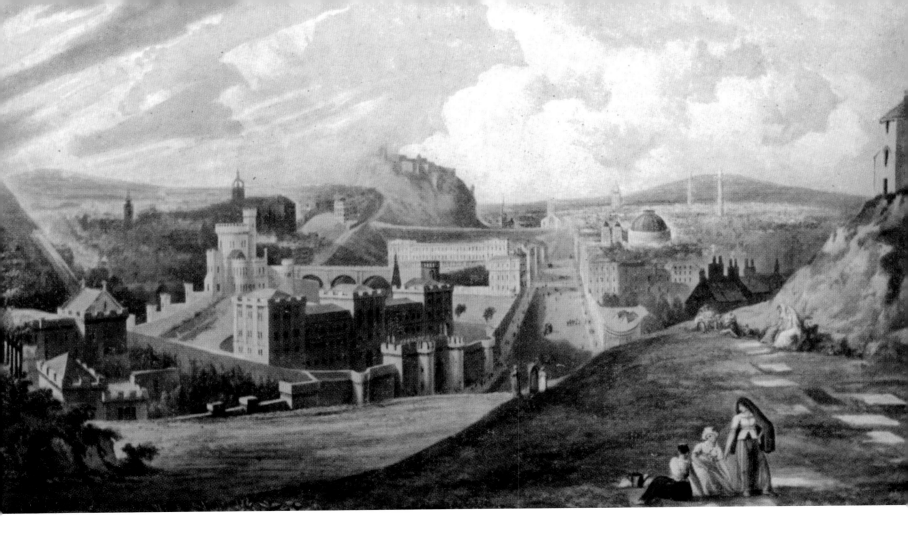

Edinburgh From Calton Hill
Aquatint by T. Sutherland, after J. Gendall.

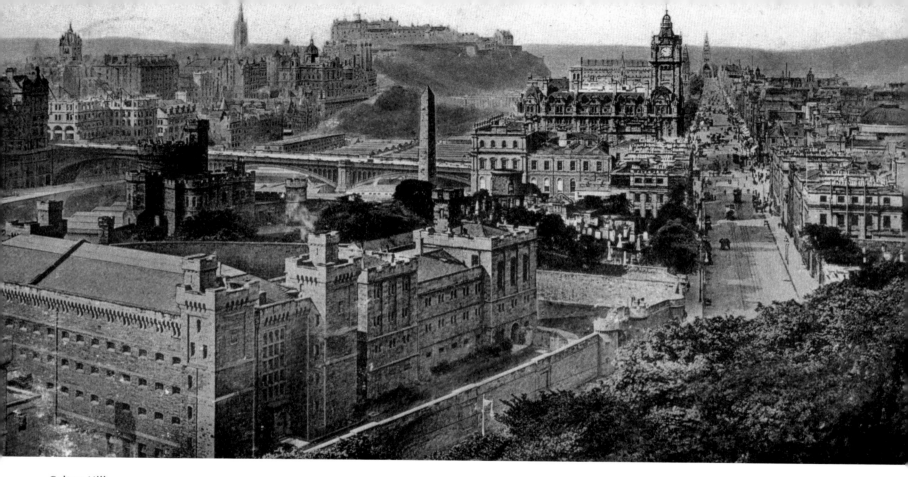

Calton Hill

This 355-foot high plug of volcanic rock was somewhat isolated from Edinburgh proper until the New Town was built, and the east end of Princes Street opened up to cross Low Calton ravine, over Regent Bridge, to Waterloo Place, in the early nineteenth century. However, 300 years earlier, it was a different picture. A Carmelite monastery lay at Greenside, but the buildings became empty after the Reformation, and it became a hospital for lepers. Hangings took place near this institution and witches were burned at the stake. The lower ground further around played host to open-air plays and tournaments, while livestock grazed the slopes. In the more enlightened 1800s, an observatory and a variety of Greek-influenced monuments arose on the hill, and the burgh of Calton became part of the city.

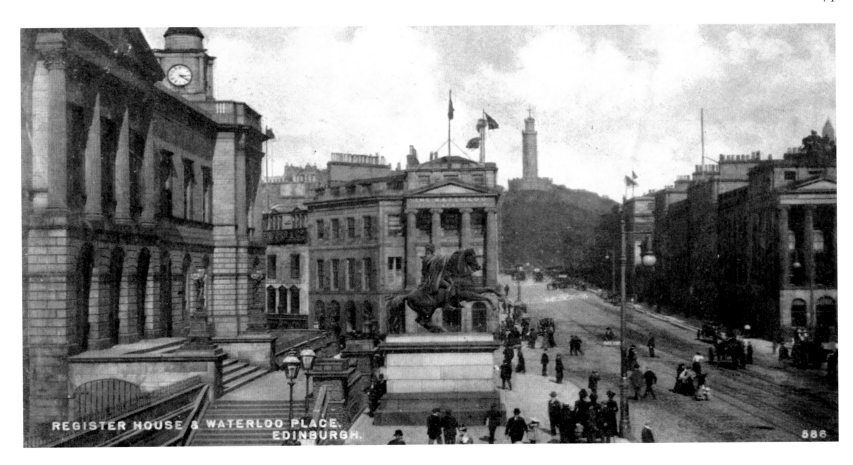

REGISTER HOUSE & WATERLOO PLACE.
EDINBURGH.

586

Register House and Waterloo Place
The rapid development of Edinburgh after North Bridge included the first Register House, built in 1774, which stood proudly facing all who crossed the bridge from Old Town. It was built on ground called Multrees Hill, thought to have been named after a plantation of mulberry trees, grown by French silk weavers living in the village of Picardy. Waterloo Place, with its elegant entrance pillars and formal, pale stone buildings, was completed by 1822, creating a fashionable thoroughfare to Calton Hill.

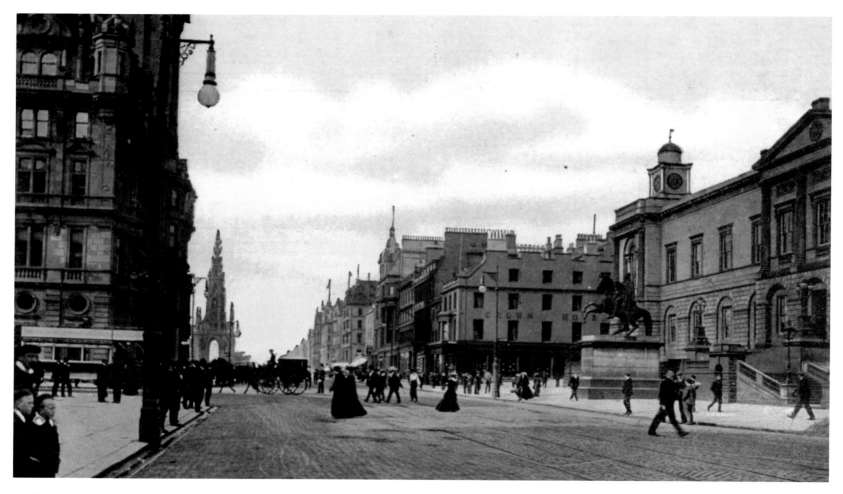

Wellington Monument and Register House
The statue of The Duke of Wellington was erected in 1852.

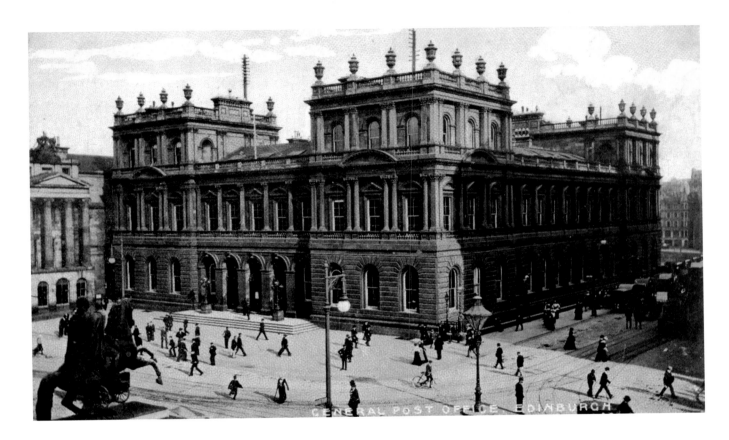

GENERAL POST OFFICE, EDINBURGH

General Post Office

From 1695 onwards, Edinburgh had a postmaster and the post office operated from a house near Parliament House. In 1819, it moved premises to Waterloo Place, which became inadequate after the uniform penny post was introduced by Rowland Hill in 1840. Letter post increased to such an extent that a new, two-storey post office was built in 1861 on the site of the much-loved old Theatre Royal. There were two further expansions as more space was required, finishing up as the immense structure seen in this photograph from the early twentieth century. By the end of the century, business had grown such that the *Ordnance Gazetteer* reported, in 1890: 'There are branch offices with money order, savings bank, insurance and annuity and telegraph departments at George Street, Lynedoch Place, and Newington; there are also throughout the city and suburbs thirty-six sub-post offices, of which twenty have telegraph departments and nearly ninety pillar and wall letter boxes.'

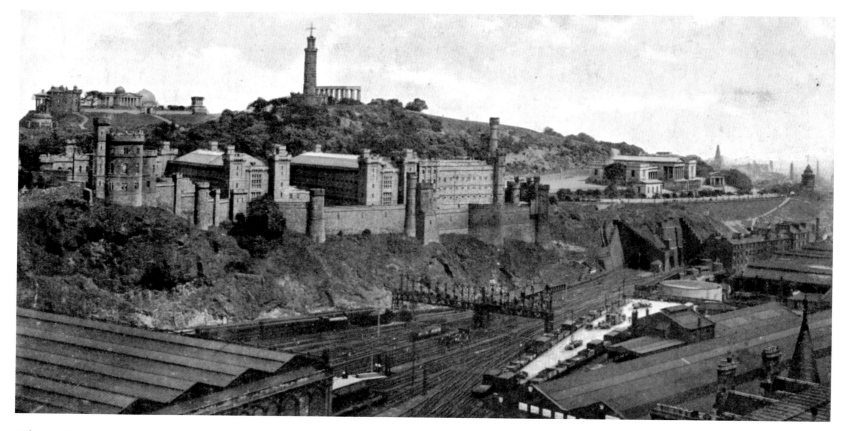

Calton Hill, Prison, North Bristol Railway

The Bridewell was built in 1796, and incarcerated offenders of petty crime. The castellated design, designed by Robert Adam, was unusual for him, but was thought to be sympathetic to the steep and prominent location on the south slope of Calton Hill. Within twenty years, the population and crime in Edinburgh had increased, the Tolbooth had outlived its life and a new prison was required. It seems remarkable that the south side of Princes Street was considered as a possible location. Old Calton Gaol, built on the site of the Bridewell, was, at that time, Scotland's largest prison. In 1815, prisoners were transferred from Old Tolbooth in High Street. It included medical quarters and a platform on top of the retaining wall for executions, which didn't cease until 1864. St Andrew's House replaced the jail, which moved to Saughton in 1926.

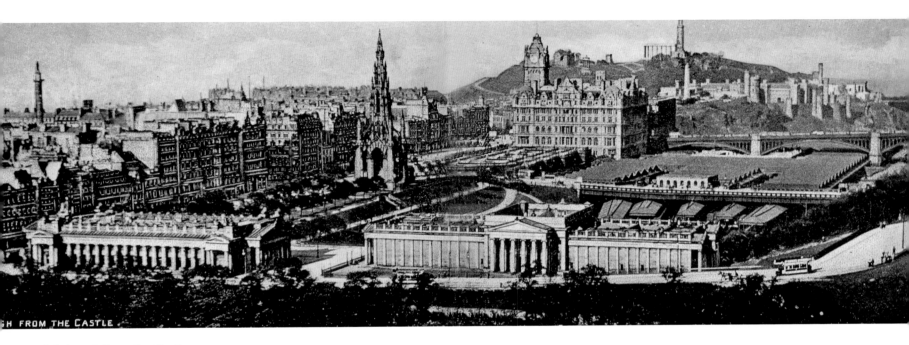

H FROM THE CASTLE.

Edinburgh from the Castle

The classic panorama over central Edinburgh is unlikely to have altered much from a century ago and, barring natural disasters, will remain so. However, there have been some close calls regarding planning. Firstly, the proposals to build on the south side of Princes Street – thankfully overturned – and the idea to build Calton Jail in the valley, and yet another, to line North Bridge with shops. A less well-known story was related by Sir J. H. A. MacDonald in *Life Jottings of an Old Edinburgh Citizen*; 'The track up the unfinished Mound went around the east side of the Royal Institution, and the empty space to the west, was occupied by four wooden structures – the Royal Rotunda, a theatre called Victoria Temple, a tanner's yard and a coach-building shed.' Street entertainers often performed around there, obviously the forerunners of the Edinburgh Festival Fringe.

Moray Place

The north-west boundary of New Town was a 13-acre estate owned by the Earl of Moray, consisting of woodland and open country that sloped down to the Water of Leith and Drumsheugh House in which he lived. The earl quickly saw the potential of his land, and undertook a development of grand, elite Georgian terraced houses (designed by James Gillespie Graham) laid out in crescents, thereby breaking the mould of James Craig's linear plan. Moray Place and Ainslie Place were the centre pieces and, to this day, are considered the most prestigious addresses in the city.

Dean Bridge
The logical direction for Edinburgh to expand, following the development of Moray estate, was to the north-west, across the steep valley of the Water of Leith. John Learmonth had purchased the Dean Estate and, wishing to emulate the success of the Earl of Moray, thought it in his interest to pay for a bridge across the valley. The 100-foot high Dean Bridge, the last design work undertaken by Thomas Telfer, was finished in 1831. It towered over the mills and tanneries of the village of Dean below, where a single-arch bridge had historically carried all traffic. During construction, a builder called Gibb reputedly charged locals a fee to look at the view. The only change since the photograph was taken has been a heightening of the parapets, to deter suicidal souls.

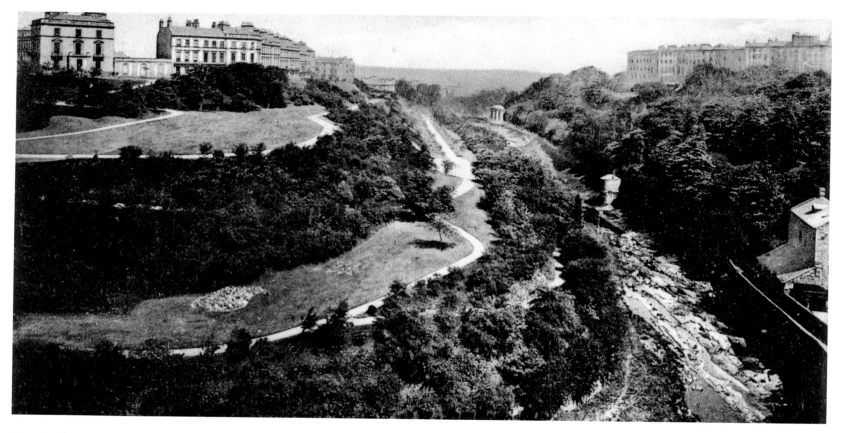

Eton Gardens

In 1855, Eton Terrace, on top of the steep ground, was finished and overlooked an area of around 7 acres, where, at that time, sheep were grazing. In the 1860s, residents decided to plant the slopes with trees and shrubs, not only for aesthetic reasons, but to prevent further terraces of housing and reduce the risk of landslips. The Dean Gardens has matured into a tranquil, sylvan space, close to the heart of the city. A precedent was set by Walter Ross in the previous century; his estate, St Bernard's, stretched between modern-day Carlton Street and Anne Street, and was laid out with woodland, orchards and gardens. At the highest point, he had a peel tower erected, known as Ross's Folly, the stonework of which incorporated various artefacts he collected from ruined buildings. Following his death, the house was occupied by Sir Henry Raeburn and, in 1825, the tower was finally demolished for new housing in Anne Street.

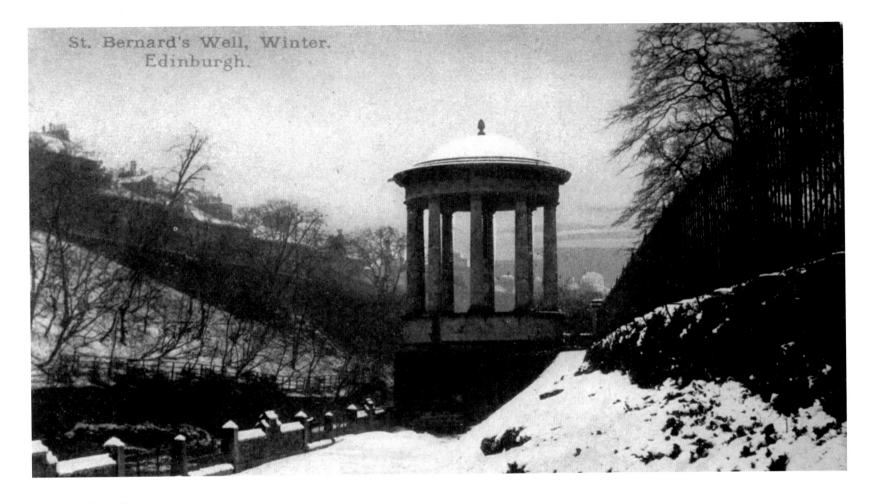

St. Bernard's Well, Winter. Edinburgh.

St Bernard's Well
The *Edinburgh Advertiser*, from 27 April 1764, carried an article stating: 'As many people have got benefit from using of the water of St Bernard's well in the neighbourhood of this city, there has been such demand for lodgings this season, that there is not so much as one room to be had either at the Water of Leith or its neighbourhood.' Dean Terrace was, in fact, named Mineral Street at that time. The spring was covered by a small well house initially, but in 1789, a Doric temple was built there, paid for by Lord Gardenstone, who found the water therapeutic.

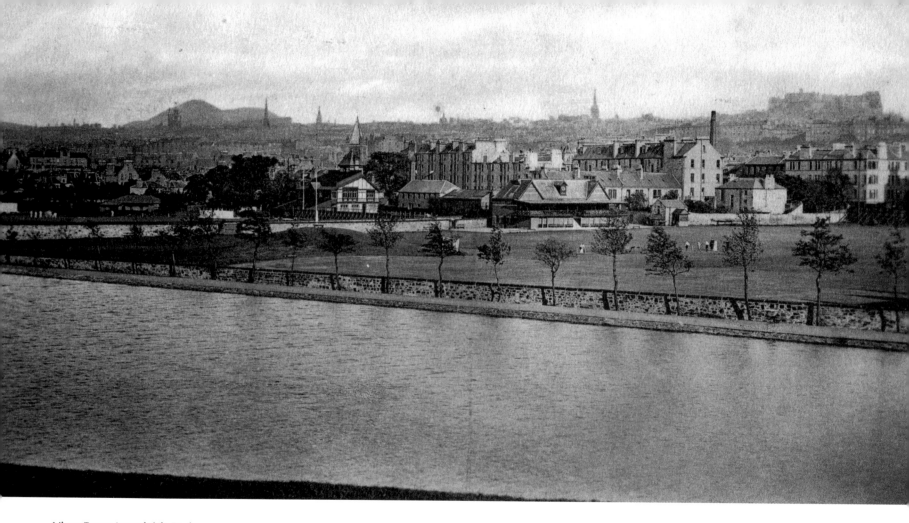

View From Inverleith Park

Edinburgh rapidly spread outwards from both Old and New Towns in the nineteenth century, encompassing villages like Stockbridge that had previously been discreet country communities. The gardens were created by the council in 1890.

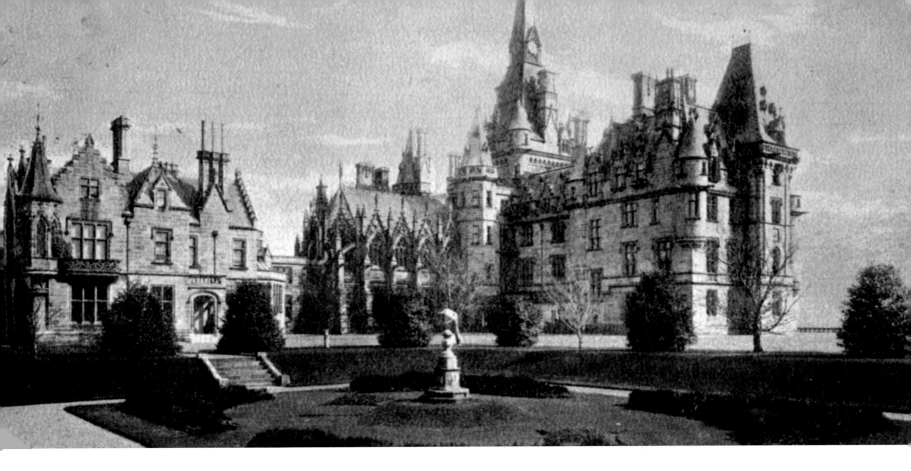

Fettes College

This impressive French Baronial school was designed by David Bryce, and took the first pupils in 1870. Sir William Fettes (1750–1836), Lord Provost of Edinburgh 1804–06, accumulated wealth from trading in tea during the Napoleonic Wars, and purchased Comely Bank estate where he lived. In 1815, his only son died and, in the philanthropic tradition of Edinburgh, he bequeathed £166,000 to build a school for orphans and needy children, in memory of his son. (James Heriot, a goldsmith and banker, was the first man to found such an institution and established Heriot's Hospital in the seventeenth century). Fettes College quickly gained a reputation for excellence, and the prestigious fee-paying establishment has the moniker 'Eton of The North', although Scots do call Eton 'Fettes of The South'.

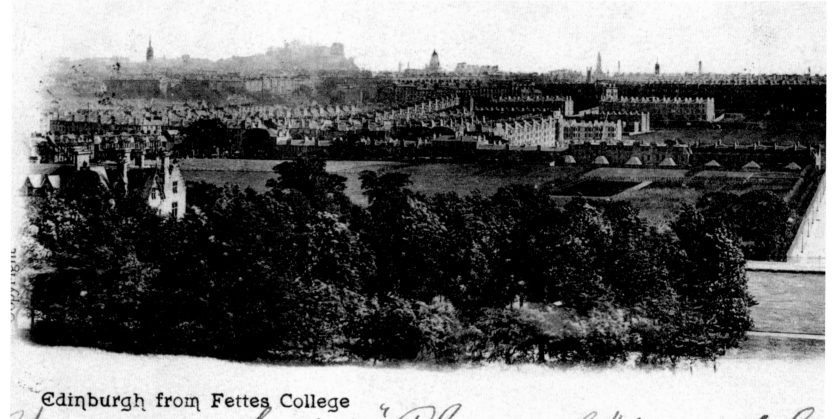

Edinburgh from Fettes College

Yes you can charter a "Phamrock" for me. Ilike
sailing. don't you? Love to all Daisy

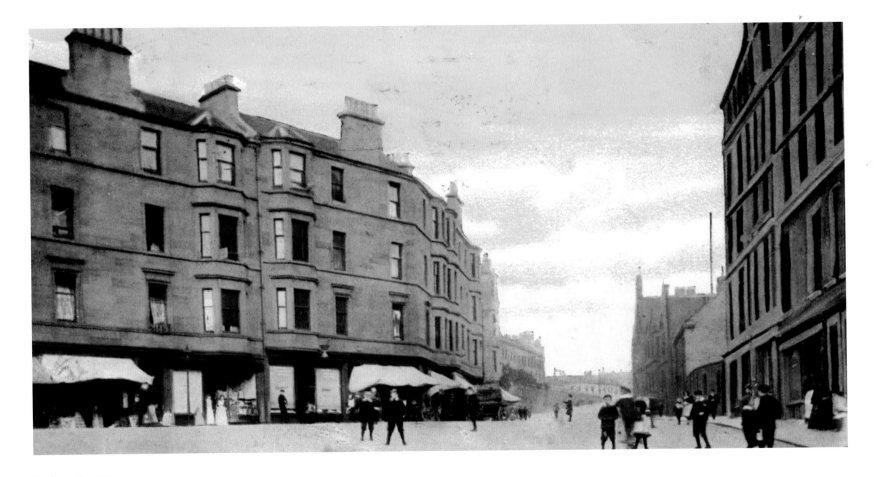

Rodney Street

This thoroughfare linked Canonmills to the Bellvue and Clarendon developments, which were built piecemeal during the Victorian era. The northern New Town, adjoining Rodney Street to the west, included Scotland Street, where a railway station was built in the 1840s (initially called Canonmills Station) from where horse-drawn trains travelled to Trinity, near Granton, to connect with ferries across the Forth to Burnisland in Fife. In 1847, the line was extended to Canal Street station – now Waverley – in the heart of Edinburgh. This involved digging a tunnel under Dublin Street, St Andrew's Square and Princes Street. The line closed after twenty-one years, but the tunnel was prepared as an air-raid shelter in the Second World War, and has recently been made into a cycleway and footpath to avoid the traffic of Rodney Street.

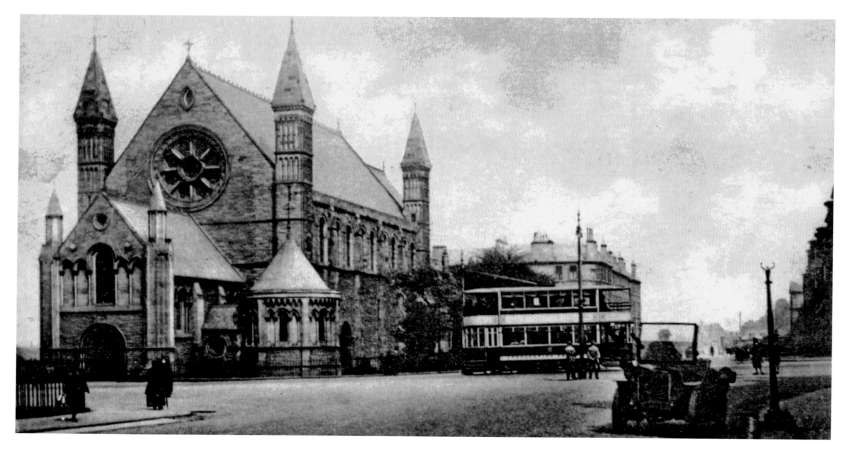

East London Street

Broughton Place estate, on whose land this church and street were built, was founded in 1807. The Catholic Apostolic church was first situated in Broughton Street, but the new one, erected in 1885, was more architecturally ornate, and decorated inside with murals by Phoebe Ann Traquair. When it ceased to be used as a church, the Edinburgh Brick Co. bought the premises, but, ten years later, sold it to the Mansefield Traquair Trust, who were anxious to conserve the wall paintings, the stained-glass windows and the general fabric of the building. Since restoration, it has been called 'Edinburgh's Sistine Chapel'.

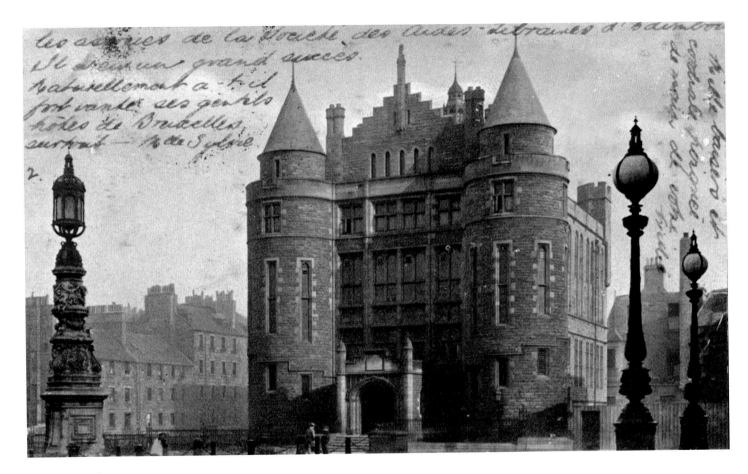

Student's Union
Teviot is reputedly the oldest purpose-built student union in the world. The sixteenth-century style of the building, the Gothic latticed windows and Renaissance architecture deceive, because it was actually built in 1889 on the site of Ross House, which was used as a lying-in hospital after it was sold in 1754. Alcohol was not sold until 1970, and women were admitted the following year. Another wing was added to the west after this photograph was taken.

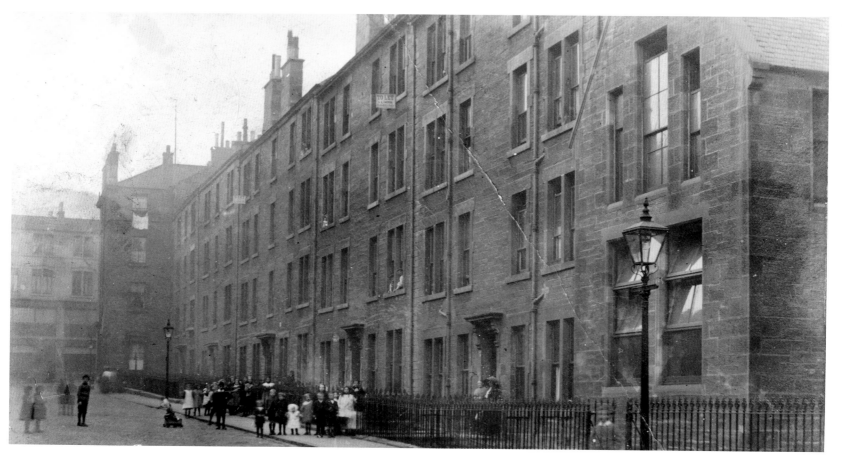

No. 100 Glen Street (*opposite*)

The area west of Lauriston Gardens belonged to the Hog family of Newliston. As Edinburgh expanded during the Victorian era, their eighteenth-century villa was cleared to make way for dense, basic, tenemented streets at Tolcross, of which Glen Street was typical. A mission house, serving the impoverished residents of nearby Portsburgh, was established in Glen Street and was later run by the Sisters of the Poor. The congregations of the churches, by whom it was run, united in 1965 to worship from the St Michael and All Saints church on Brougham Street. A narrow, atmospheric close offers a shortcut from the dead-end at the foot of Glen Street to the church.

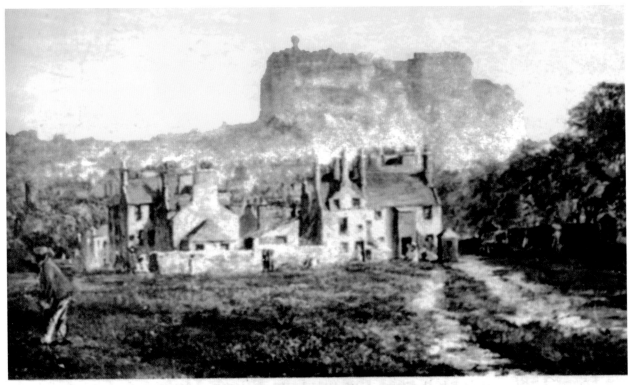

The old village of Wrychtishousis

No. 100 Glen Street (*opposite*)
The area west of Lauriston Gardens belonged to the Hog family of Newliston. As Edinburgh expanded during the Victorian era, their eighteenth-century villa was cleared to make way for dense, basic, tenemented streets at Tolcross, of which Glen Street was typical. A mission house, serving the impoverished residents of nearby Portsburgh, was established in Glen Street and was later run by the Sisters of the Poor. The congregations of the churches, by whom it was run, united in 1965 to worship from the St Michael and All Saints church on Brougham Street. A narrow, atmospheric close offers a shortcut from the dead-end at the foot of Glen Street to the church.

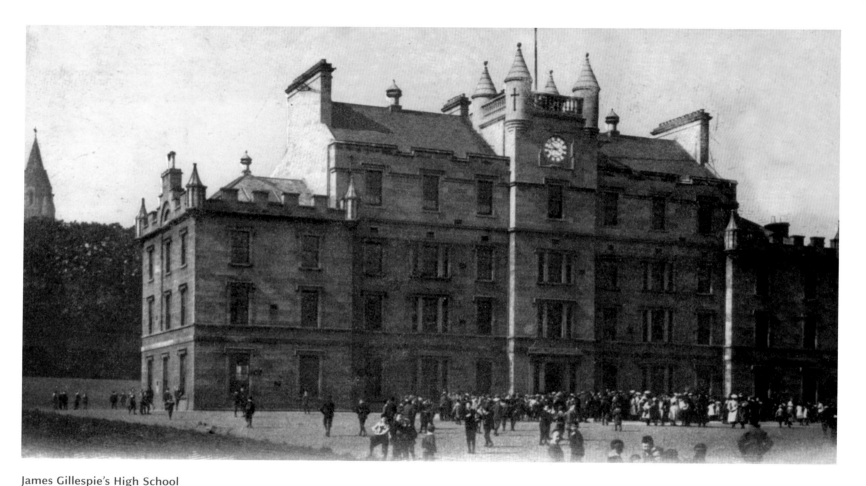

James Gillespie's High School

In 1695, Bruntsfield House and the estate was sold to the Warrender family of Lochend and, over the next 200 years, they acquired the adjacent land. In the eighteenth century, Bruntsfield Links was used for sheep grazing, golf and quarrying (quarry remnants are still visible). The death of Sir George Warrender, in 1901, left Bruntsfield House unoccupied and, after years of neglect, it was almost demolished in 1935. Edinburgh Corporation managed to purchase it from the trustees, with the proviso it be used for the public good. The mansion was utilised during the Second World War, but soon after became the preparatory department of James Gillespie's High School for Girls.

Merchiston Castle

Another south-side mansion was the fifteenth-century Merchiston Tower, which belonged to Alexander Napier, whose grandson, John Napier, was responsible for inventing the mathematical system of logarithms, published in 1614. He was the first to conceive the notion of decimal points, earning him the nickname the 'wizard of Merchiston'. The property was altered, both in structure and usage, at various times during the 500 years under Napier family ownership, until, in 1935, Edinburgh Council acquired it, and developed a technical college complex around the epicentre of the tower. Napier Technical College (now Edinburgh Napier University) opened in 1964, after six years of restoration had been spent on the tower.

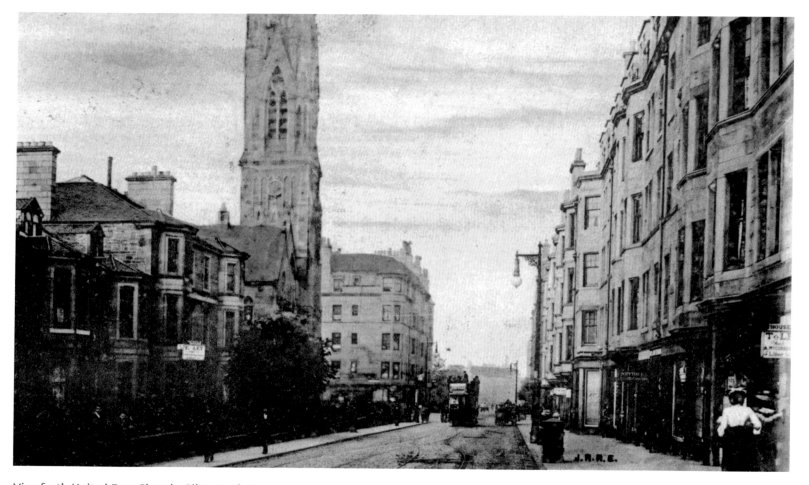

Viewforth United Free Church, Gilmore Place
Built in 1871 (as the Free church) in a geometric Gothic style, it became Viewforth St David and St Oswald, and is now Kings church, Edinburgh –
a charity.

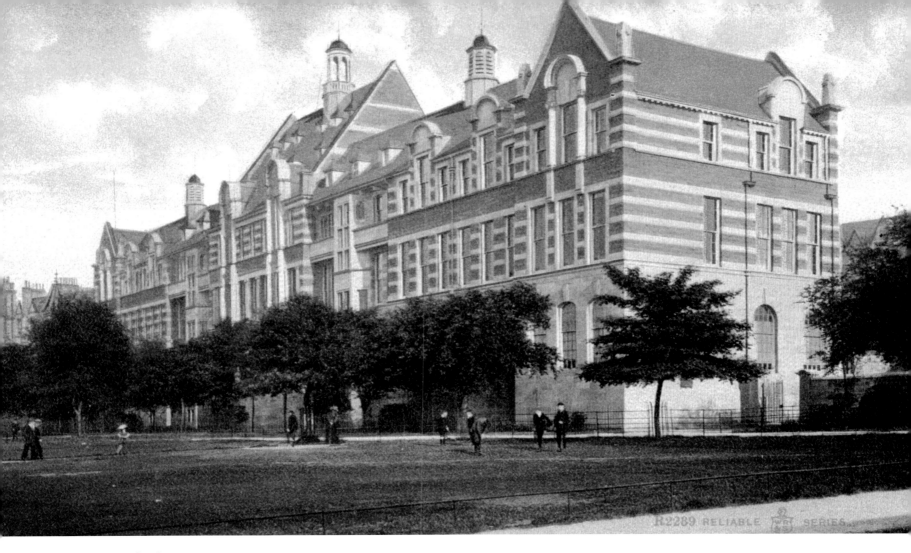

Boroughmuir School

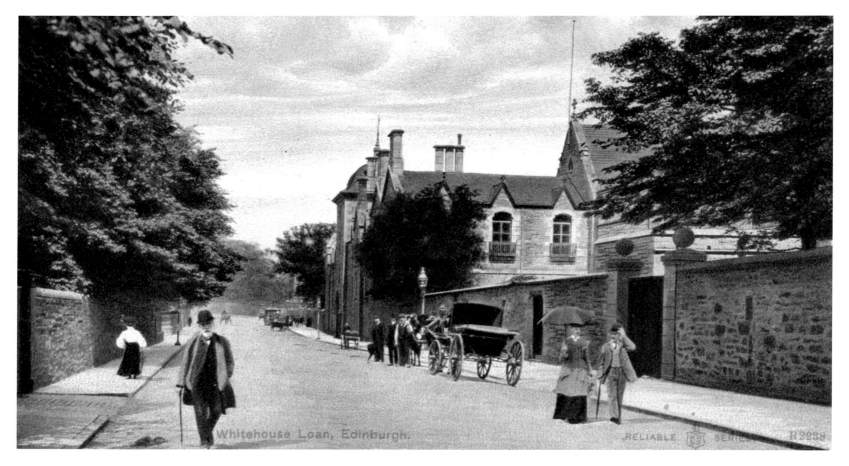

Whitehouse Loan, Edinburgh.

RELIABLE SERIES R2238

Whitehouse Loan

The rural environs of Burgh Muir were favoured for the isolation of plague victims, which spread fast in the confined, airless and insanitary conditions in Old Town. When the Great Plague struck in 1585, the owners of large houses in that area were obliged to quarantine the sick. The Whitehouse mansion was occupied by Lady Cliftonhall, who vehemently objected to the victims being in her home and won her case against the town council. However, five years later, the very same lady was found guilty of witchcraft and burnt at the stake on Castlehill. The building became known for a better reason in 1834, when the first post-Reformation convent was founded there by Revd, later Bishop, James Gillis, dedicated to St Margaret. It is now a theological administration centre and library named The Gillis Centre.

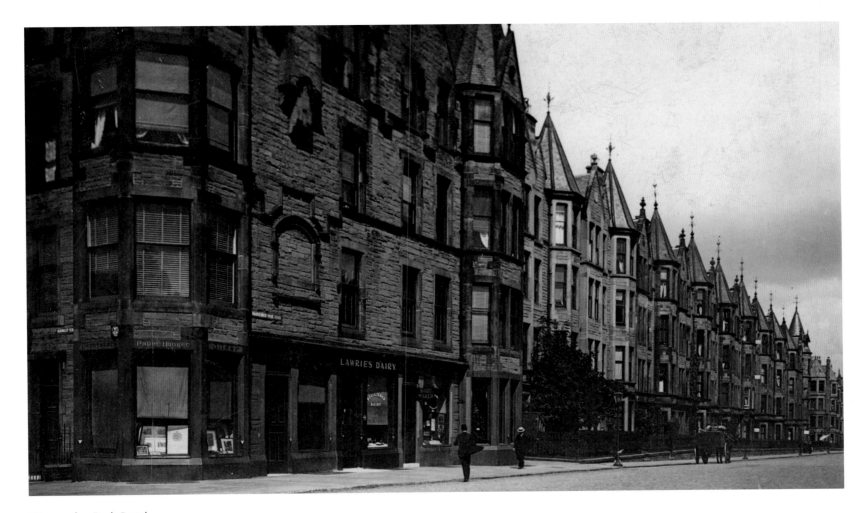

Warrender Park Road

Sir George Warrender of Lochend, who lived at Bruntsfield House and owned the surrounding land, was shrewd enough to realise the possibilities for feuing his estate, having seen the fast expansion of Edinburgh to the north. A large-scale plan was undertaken between 1869 and 1880 to develop Marchmont, with all the street names associated with his family – hence Thirlestane, Spottieswoode, Arden. Isabella Lawrie, dairykeeper is listed in the 1908 post office directory.

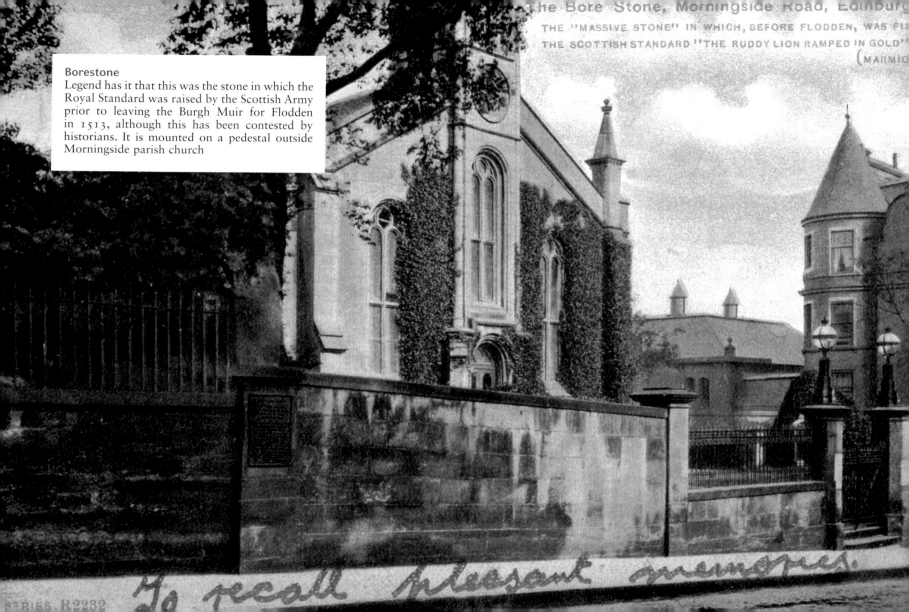

Borestone
Legend has it that this was the stone in which the Royal Standard was raised by the Scottish Army prior to leaving the Burgh Muir for Flodden in 1513, although this has been contested by historians. It is mounted on a pedestal outside Morningside parish church

To recall pleasant memories.

SERIES R2232

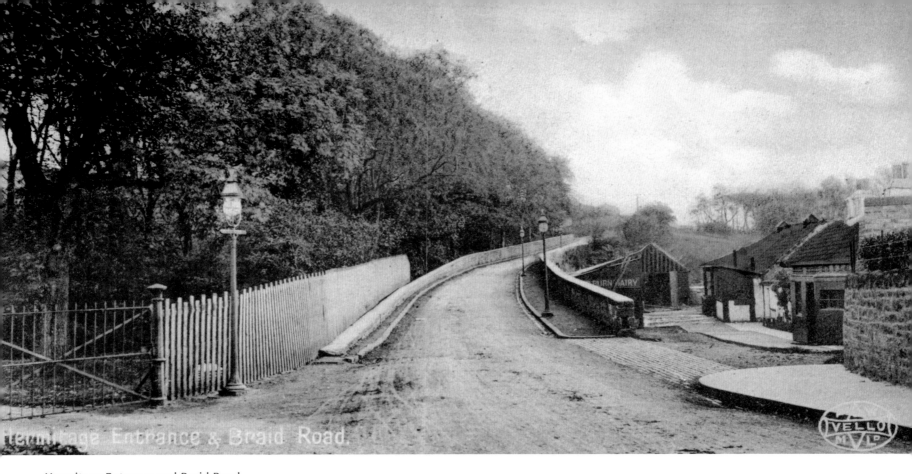

Hermitage Entrance & Braid Road.

Hermitage Entrance and Braid Road

Hermitage of Braid, in woodland between Braid Hills and Blackford Hill, was built for Charles Gordon of Cluny in 1785. At the time, the area, unlike the north of Edinburgh, was undeveloped rural farmland. Morningside, half a mile down the hill, consisted of a handful of thatched cottages, a smithy and an inn, and the great expansion in this district occurred in the late 1800s, accelerated by the introduction of horse-drawn trams in 1872, and the opening of the suburban railway in 1884. Hermitage House was gifted to the nation in 1937 by the owner, John McDougal, and is used as a visitor centre within a nature reserve. The toll house from Morningside was dismantled and rebuilt as the lodge opposite, which was the Braidburn Dairy, also known as Duff's Dairy, and was one of several in the district, though is now demolished.

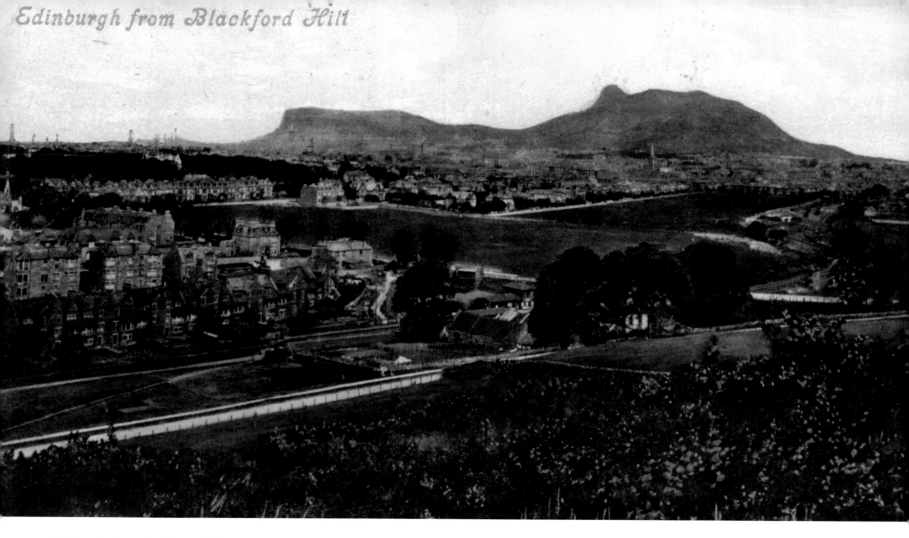

Edinburgh From Blackford Hill
This viewpoint of the city has been favoured by engravers and artists over the centuries.

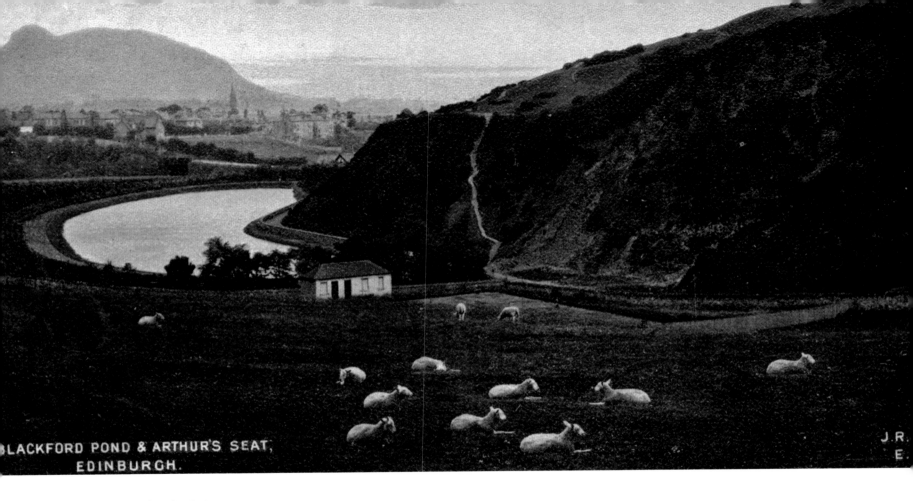

BLACKFORD POND & ARTHUR'S SEAT,
EDINBURGH.

J.R.
E.

Blackford Pond and Arthur's Seat
This is a shallow, man-made pond, but the hollow in which it lies was glacially formed and was used for both curling and skating. In 1848, Merchiston Curling Club was oversubscribed, and a group broke away to form Waverley Curling Club, using Blackford Pond instead. The valley in which this lies, is that of the Jordan Burn, and the land belonged to Egypt Farm. These names, together with nearby Canaan, Eden and Goshen, led one author to call it ' Edinburgh's Bible Belt', but the reason for the nomenclature is not known. The pond and surrounding have belonged to Edinburgh City Council since 1906.

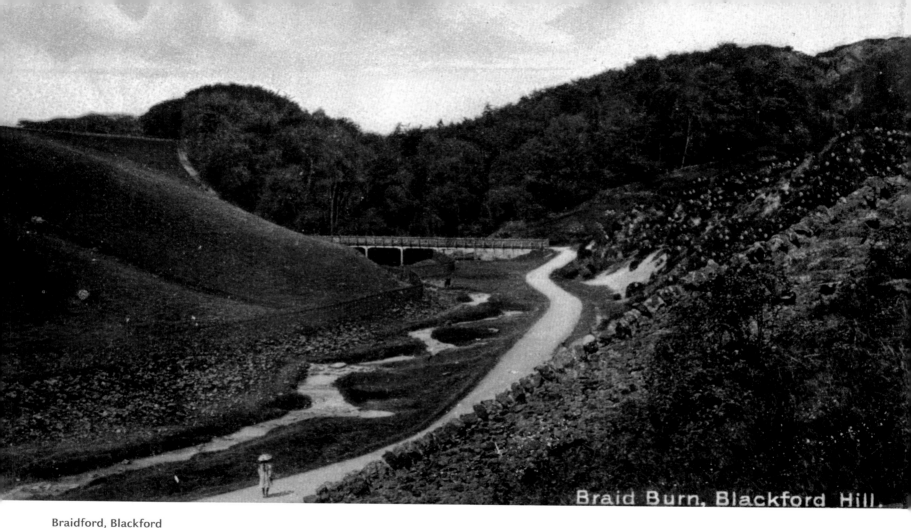

Braid Burn, Blackford Hill.

Braidford, Blackford
Blackford Hill was part of the Mortonhall Estate, but was sold by the owner, Lt-Col Henry Trotter, to Edinburgh Corporation, in 1884, for £8,000. After which, it became a very popular location for walkers, artists and photographers, providing a splendid panorama across the city, to Fife and beyond.

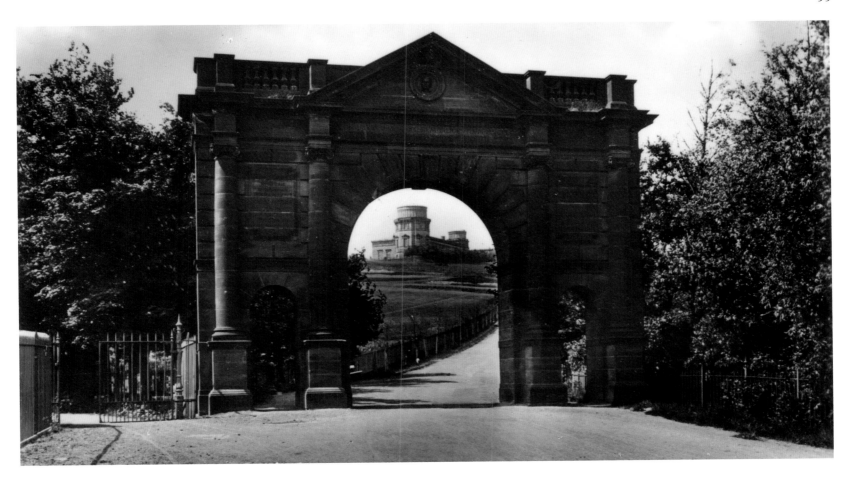

East Entrance, Blackford Hill
This track led to Blackford Quarry (closed in 1952), which replaced the previous one on Salisbury Crags in 1826. The hill and its eastern slope are another example of the crag and tail geological feature, which date from the Ice Age, a fact verified by the Swiss-American geologist, Louis Agassiz (1807–73), who was the first to recognise glacial action here.

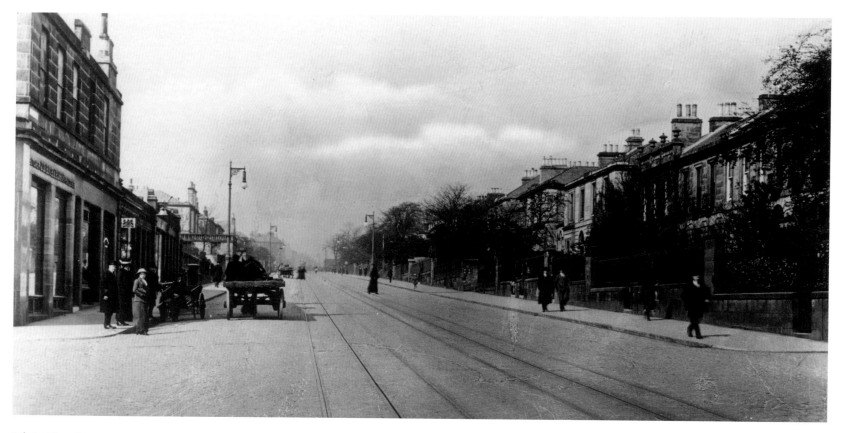

Minto Street

Newington was purely open countryside until the South Bridge, completed in 1788, opened up a route southwards, which was the catalyst to development in this direction. Residents of the New Town, although appreciating their cleaner, smarter accommodation, were looking for more privacy and their own garden. By 1795, Newington land was being feued, and building began over the next few years with tenements close to town, but spreading to villas with their own gardens along Minto Street. By 1865, Newington had become the most densely populated area of southern Edinburgh and, over the next twenty years, Mayfield was also covered by villas. There are ornate stone pillars at the entrance to Blacket Avenue, on both Minto Street and Dalkeith Road, which led to Newington House, built in 1805, but demolished in 1966.

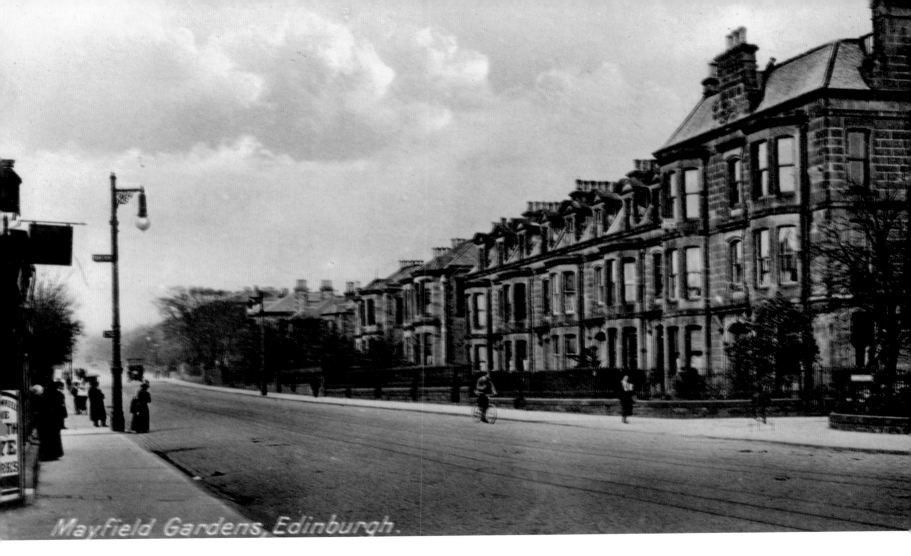

Mayfield Gardens, Edinburgh.

Mayfield Gardens

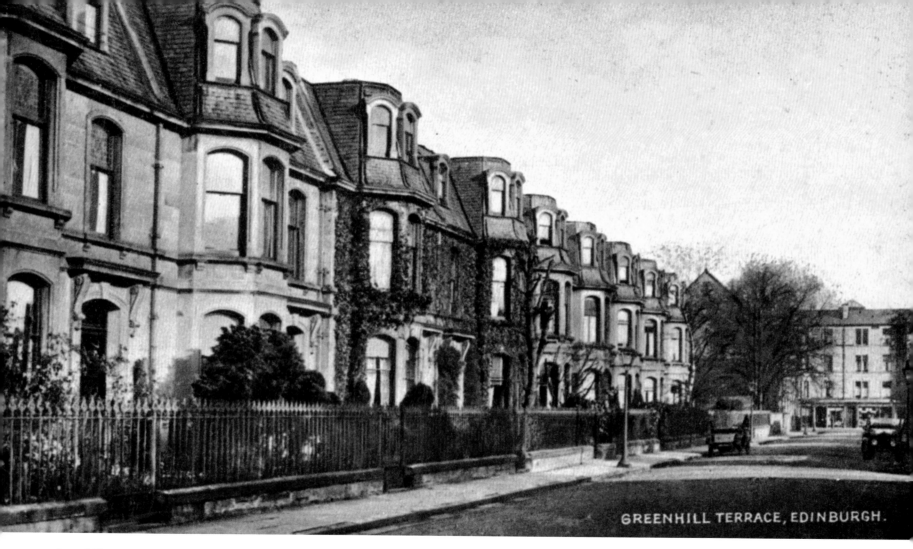

GREENHILL TERRACE, EDINBURGH.

Greenhill Terrace

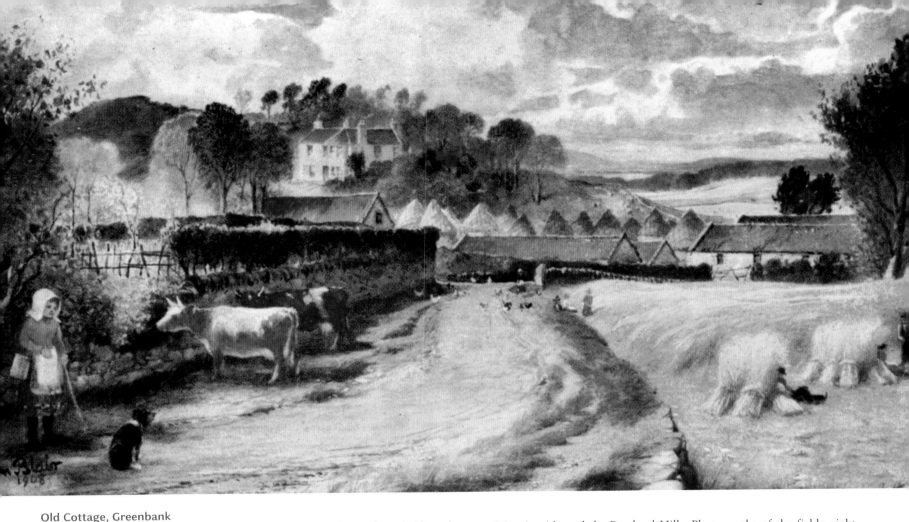

Old Cottage, Greenbank
Greenbank Farm was situated above the valley of Braidburn, about halfway between Morningside and the Pentland Hills. Photographs of the fields, right up until the 1920s, show them full of haystacks. In 1910, housing began to encroach this farmland with Greenbank Crescent, and this old cottage was lost to suburbia.

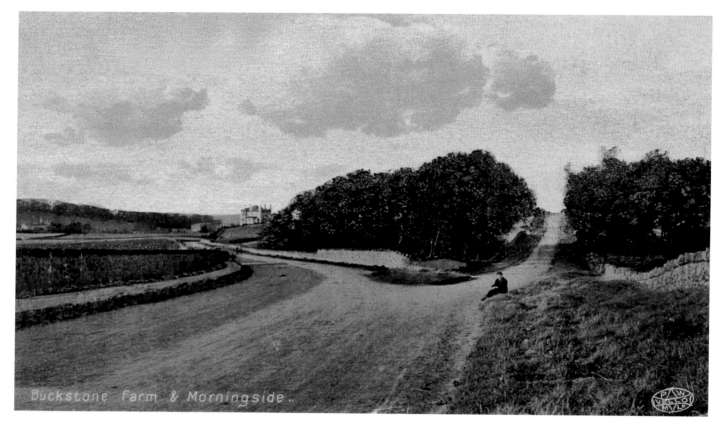

Buckstone Farm & Morningside.

Buckstone Farm

This photograph, looking north, shows the route from Biggar, used for centuries to bring farm produce to Edinburgh. Braid Road, on the right, was a narrow lane passing Mortonhall Golf Clubhouse (1892) and Buckstone Farm. This outer suburb of Edinburgh was not built up until the twentieth century, eventually covering the land of Comiston House and Buckstone Farm. At this time, the now busy crossroads at Fairmilehead consisted of two cottages, a wooden signpost and a milestone. A large standing stone, the Caiy Stane (thought to be Neolithic), stood nearby, and is now displayed in a niche in Caiystane View. The Art Deco Hillburn Roadhouse was built in 1937 on the Biggar road just below Fairmilehead, with a skittle alley in the basement, but this closed recently and was cleared away for housing.

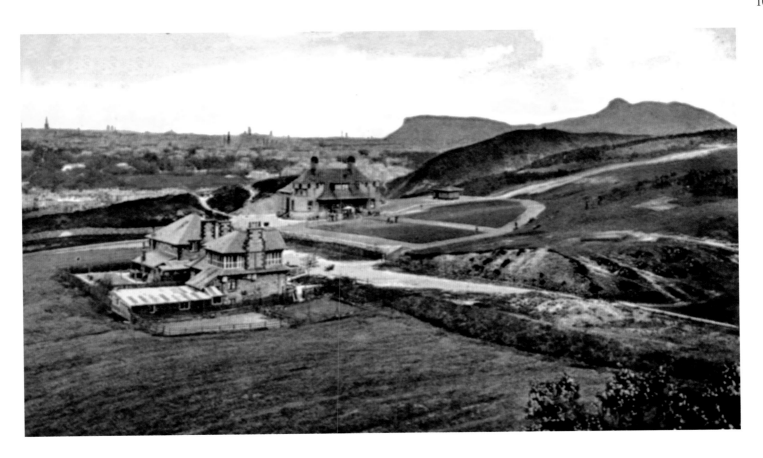

Braid Hills Golf Course

In 1899, Edinburgh Corporation purchased the Braid Hills, laying out a municipal golf course over the next few years. The panoramas from the elevated location south of the city attracted golfers who previously played on Bruntsfield Links and, by 1897, a house was built to accommodate a greenkeeper, superintendent and professional shop, as seen in the photograph. On the east side of the course was a small body of water, popular with skaters, although not with the golfers. It was drained in the mid-1920s, despite a campaign to keep it. Nearby, Winchesters refreshment rooms provided sustenance, despite the house not having gas, electricity or running water.

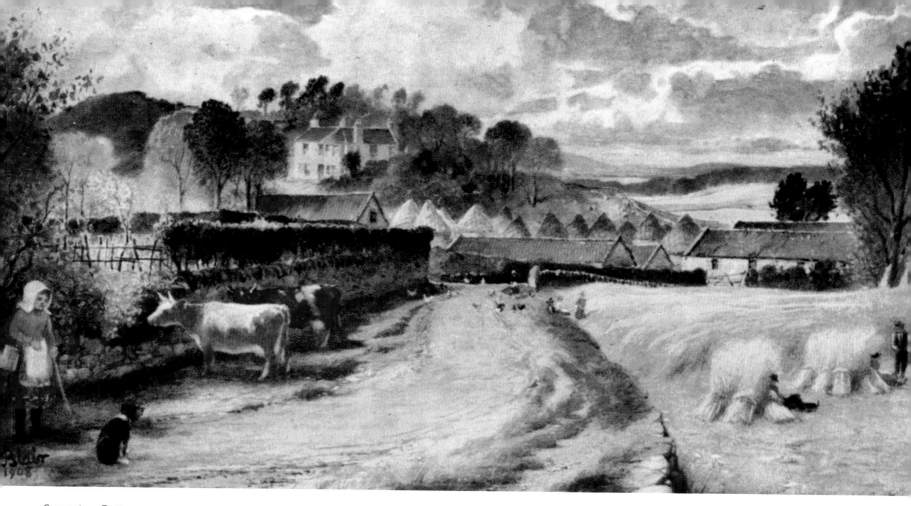

Swanston Cottage
The first supply of piped drinking water for the Old Town was taken from Comiston Springs in 1621, but, by 1758, it was insufficient and Parliament passed an Act for water to be drawn from Swanston to augment the flow. A cottage was built next to the filter beds as a meeting place for water baillies and, by 1835, this had been enlarged to a sizeable house, best known as the summer retreat of Robert Louis Stevenson and his family between 1867 and 1880.

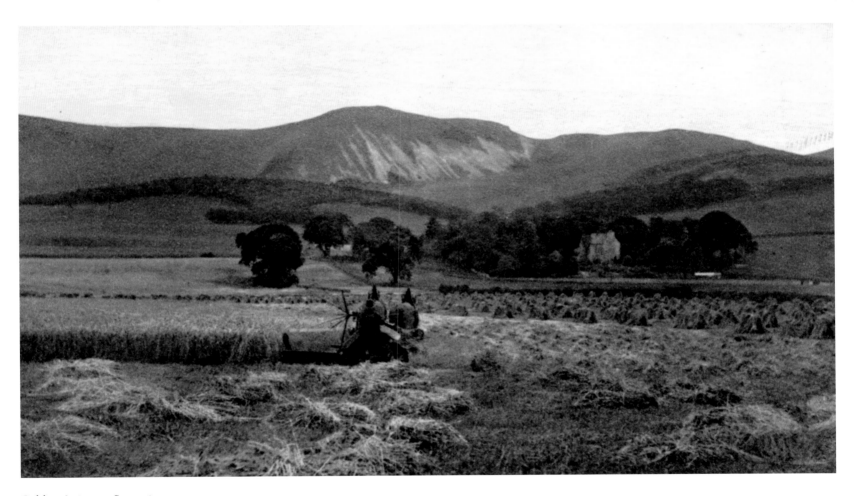

Golden Autumn, Swanston
Swanston hamlet consisted of a farm, thatched cottages for farm labourers and a school to which pupils travelled from surrounding dwellings. It nestled below the slopes of Caerketton in the Pentland Hills, and was remote from Edinburgh until urbanisation spread to within half a mile of it during the twentieth century. The cottages had fallen into disrepair by the 1960s, but Edinburgh Council decided to renovate them, and rethatched the roofs using material from the reed beds in the Tay estuary.

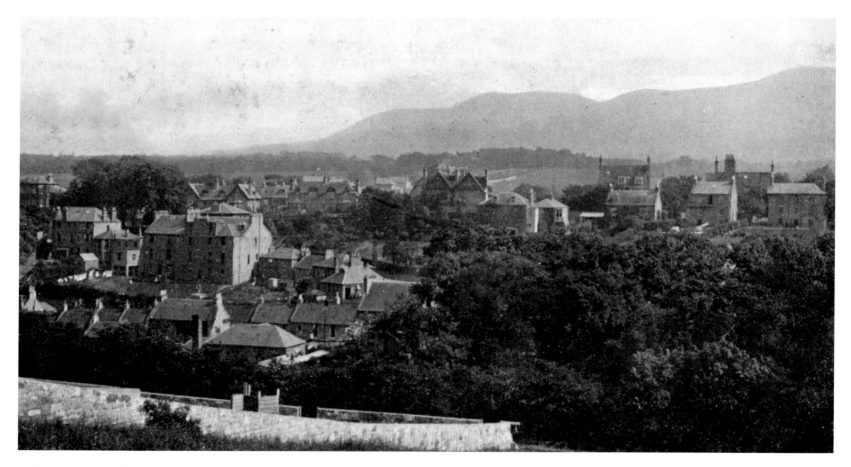

Colinton from the North

The Water of Leith was the only river (albeit a modest one) flowing through Edinburgh. Consequently, it was peppered with mills along its 23-mile course; in its most industrial period, there were seventy-six working mills, many of which produced paper. Colinton was home to a large number of them, including paper, textile, wood flour (for linoleum), grain and snuff mills – none of which operate today. Redhall Mill printed paper for the first banknotes in 1718. In 1874, the Caledonian Railway line opened a branch line from Slateford to Balerno, with stations at Colinton and Juniper Green. The line closed in 1967, and the track is now a cycle path and walkway.

Colinton Bridge
Before this bridge was built, the road through the village crossed the Water of Leith by means of the eighteenth-century single-arch stone bridge next to Colinton Parish church, where the grandfather of Robert Louis Stevenson was minister. The present viaduct dates from 1874 and spans the Spylaw estate, the parkland having been bought by Edinburgh Council in 1911. Spylaw House was built in 1773 by James Gillespie, who made a fortune from his snuff mill and tobacconists shop in High Street, and used the money to found James Gillespie's Hospital, a charitable establishment for educating and caring for poor boys.

Colinton Mains Hospital

There was a fever hospital in the high school yards of Old Town, whose size and location became inadequate for treating outbreaks of infections, such as smallpox, tuberculosis and diphtheria. An elevated, airy site was chosen near Craiglockhart Hills for Robert Morham's new hospital, which was designed with the contemporary medical opinion in mind, with parallel lines of pavilions on which were balconies for patients to take the air. Separate cottages were also provided for isolation. The opening ceremony took place in 1903. Since that time, the City Hospital, as it was later named, has closed and converted to attractive houses, retaining the red stonework.

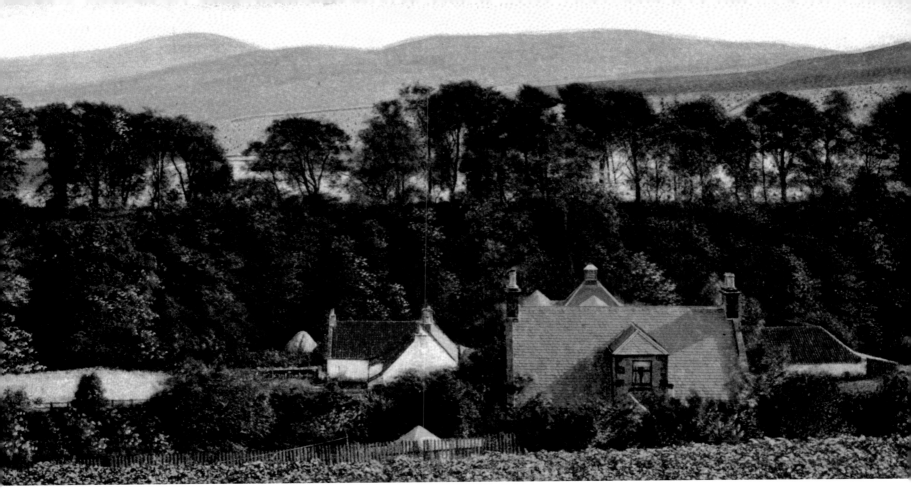

Pentland Hills and Mill, Juniper Green
The photograph illustrates the steepness of the valley of Water of Leith and the suitability of the location for driving mill wheels. Juniper Green was a community just upstream from Colinton and, in the eighteenth century, seven mills operated here. The water flow was very variable, so a series of lades sluices and weirs were constructed and, later on, three reservoirs – Harperrig, Threipmuir and Harlaw – were made at the foot of the Pentland Hills to back up the water supply.

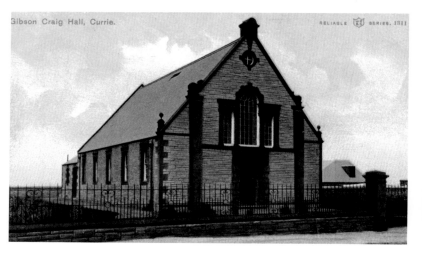

Gibson Craig Hall, Currie.

RELIABLE SERIES. 1311

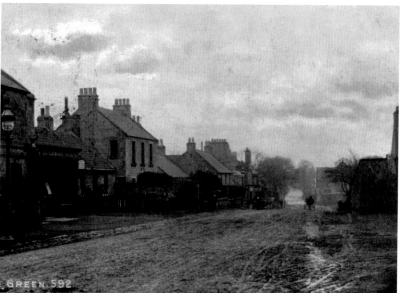

GREEN 592

Above right: **Church and Bridge, Currie**
Church records from 1599 mention bridge repairs, suggesting this fording point has existed for over 500 years; the present structure was built in 1896. There has been an ecclesiastical site in Currie for more than 1,000 years. In 1296, the Archdeacon of Lothian chose Kildeleith (the former name for Currie) as his headquarters, but the structure has been changed several times since then. The architecturally attractive church of today was built in 1784, and sits on a gentle verdant slope above the Water of Leith.

Above left: **Gibson Craig Hill**
The church hall of Currie Kirk was named after Sir William Gibson Craig, MP for Midlothian in 1837–41, and whose family owned Riccarton estate, gifted to the University of Edinburgh in 1969.

Left: **Juniper Green**
This was the road leading west to Lanark and the Clyde. In the seventeenth century, the area was moorland on which people were hanged. As the city rapidly expanded in Victorian times, and the railway facilitated accessibility, a ribbon of villas were built on the north side of the route, followed later by development on the south. Eventually, the urbanisation spread through to Currie and Balerno, swallowing up the old village. Remnants of the mills can still be seen among the vegetation, and some have been converted to modern houses.

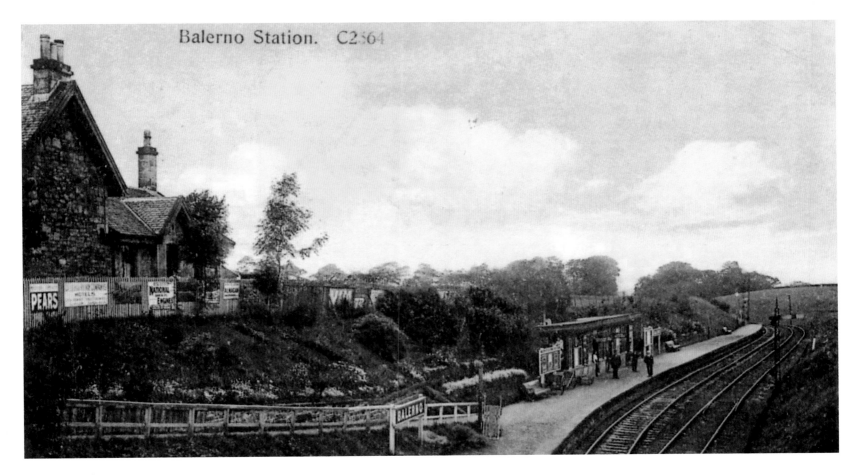

Balerno Station. C2364

Balerno Station

In 1874, the Caledonian Railway opened this route from Edinburgh. The branch left the main Edinburgh to Carstairs line at Slateford, thereafter calling at Colinton, Juniper Green, Currie, and Balerno, then on to Ravelrig, where the train turned around (it was known as the Balerno Loop). Initially, it was set up as a freight service for the mill industries in the Water of Leith valley, but passengers soon began to use it as a means of spending a day in the countryside. The topography caused challenges during construction, as the line ended up with twenty-eight bridges, a long tunnel at Colinton and a lot of embankments. The only passing place on the single track was at Currie. As the twentieth century progressed, and competition from motor transport increased, rail passenger traffic declined, and eventually stopped in 1943. However, freight continued until 1965, when Kinleith paper mill shut.

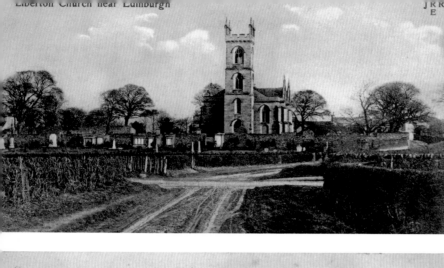

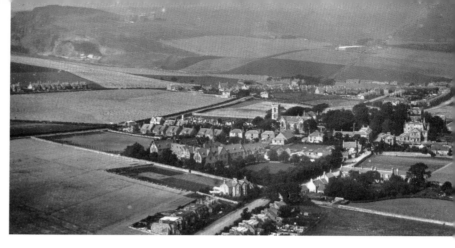

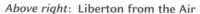

Above right: Liberton from the Air

This shows the village when it was still a rural community distinct from Edinburgh – the prominent features being Liberton Kirk and St Hilda's School for Girls to the right of it, with Lasswade Road cutting through the centre. Nether Liberton community was at the foot of the hill, but Liberton Brae to the left had not yet been developed. In 1910, the shops and houses at Braefoot were erected, and the agricultural land thereafter filled up, with housing gradually changing the area into an Edinburgh suburb. The lower area of Liberton in particular has altered beyond recognition, although the observant can still catch glimpses of boarded-up, derelict cottages of Nether Liberton poking up from patches of overgrown wasteland.

Above left: Liberton Church

Leftt: Liberton Crossroads

The Gothic spires of Liberton Kirk are a landmark seen from all around, perched as it is at atop a hill. This road leading to Kirkgate comes from the westerly area of Upper Liberton, where the late medieval (but recently restored) edifice of Liberton Tower presides over a commanding view north to the city. The Little family resided here and also built the crow-stepped Liberton House around 1600. Until 2004, there was a most unusual public toilet next to the shops at the crossroads. It was in the house of No. 6 Liberton Gardens, and entered through the semi-circular conservatory; unfortunately, it closed in 2004.

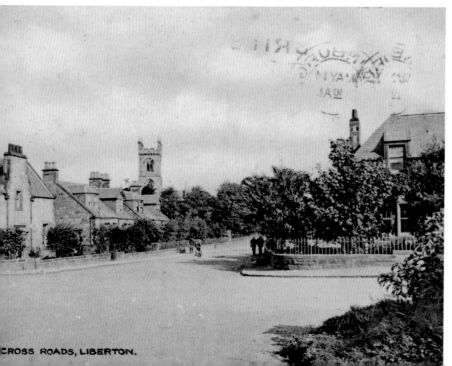

CROSS ROADS, LIBERTON.

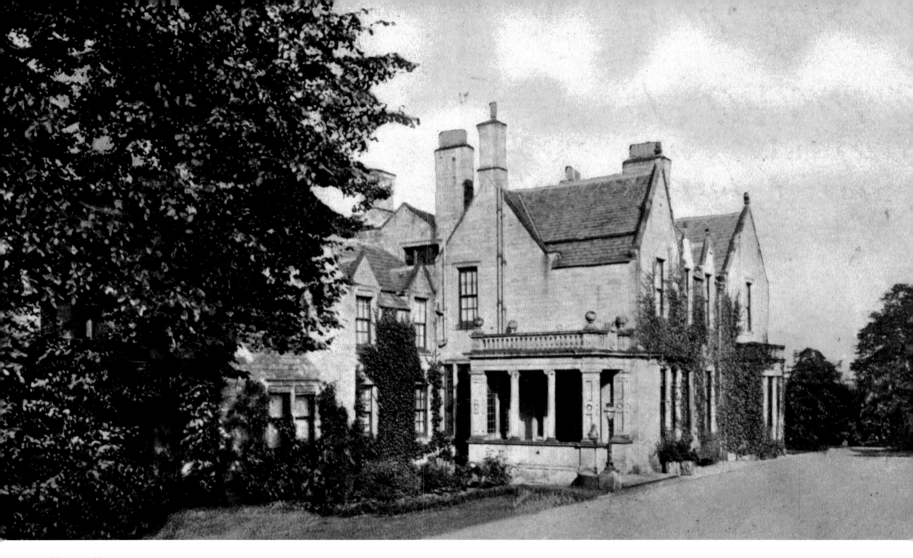

Morton House

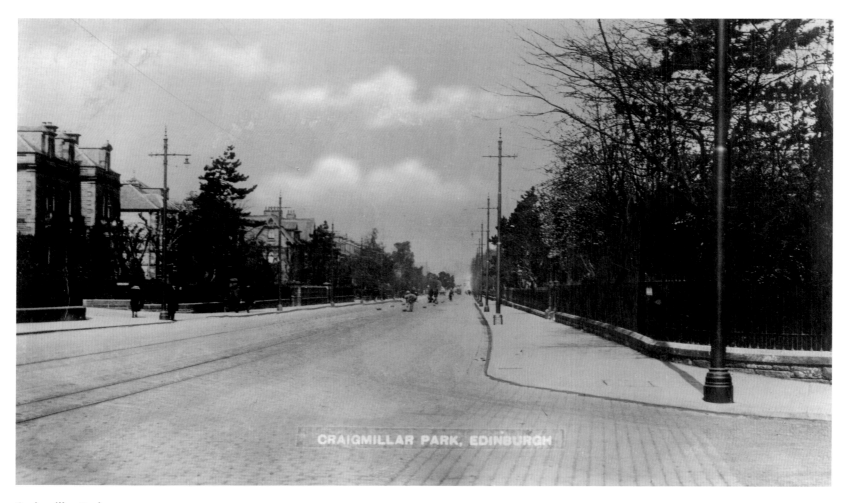

CRAIGMILLAR PARK, EDINBURGH

Craigmillar Park
Minto Street was one of the three routes leading out of Edinburgh to the south. The villas built there, and in Mayfield, soon extended along Craigmillar Park to Nether Liberton. Craigmillar Park Free church, of 1898, stood at the end of East Suffolk Road. By the 1970s, it was no longer in use, and was purchased by nearby St Margaret's School for conversion to a hall.

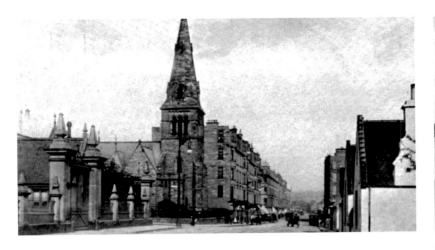

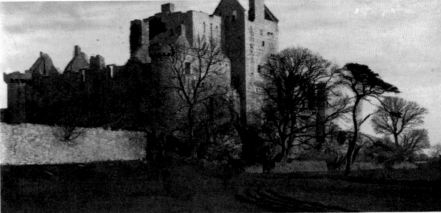

Above right: Craigmaillar Castle

Above left: Haymarket Terrace

Haymarket Terrace was the southern boundary of the western New Town, which began in the early 1800s, and initially followed a plan around Melville Street. Gradually, it spread across the old Wester Coates estate. The name Haymarket, however, is synonymous with the station, which opened in 1842 as the terminus for the Edinburgh and Glasgow Railway, until the 3,000-foot tunnel was dug under St Cuthbert's church graveyard, through Princes Street Gardens to Waverley, in 1846. The station has recently undergone a £25-million modernisation, having been under threat of relocation, in 2003, when plans for the new tramlines were being drawn up. It survived, due to public opposition and, when the tram works were being done in West Maitland Street, archaeologists discovered a vast chamber that had been used as the pulley room for the previous (nineteenth-century) generation of trams. In addition, it had been modified as a Second World War bunker.

Right: Horse Car From 1890

In 1871, Edinburgh Street Tramways Co. started running horse-drawn trams from Haymarket, along Princes Street, to Leith. Other routes were also started, operated by local companies, until Edinburgh Corporation became responsible for all city routes in 1897. Cable traction began to replace horsepower from 1889, until the last one to Craiglockhart was pulled in 1907.

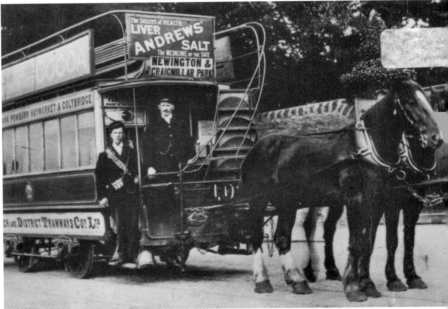

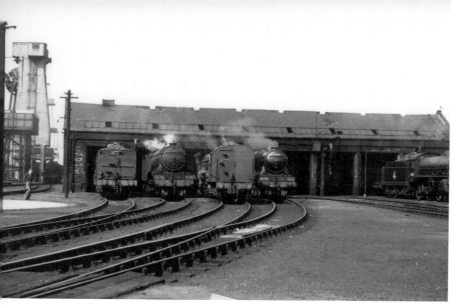

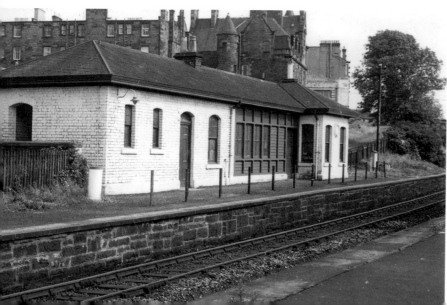

Above left: **Haymarket Engines**
Steam engines have not been seen at Haymarket since 1963, when their service was replaced by diesel. The iron train shed was dismantled and reconstructed at the Bo'ness & Kinneil Preservation Railway on the Firth of Forth.

Below left: **Gorgie East Station**
In 1884, the Suburban & Southside Junction Railway was opened for passengers and freight transport around the southern areas of Edinburgh. There were several industries in the vicinity of Gorgie, including a glue factory, McVitie & Price Biscuit factory and the North British Distillery, which merited the station being built. In 1962, the line closed to passengers but remains in use for freight and, in the last decade, campaigners have fought to run passenger trains once more. So far, this has been turned down on economic grounds.

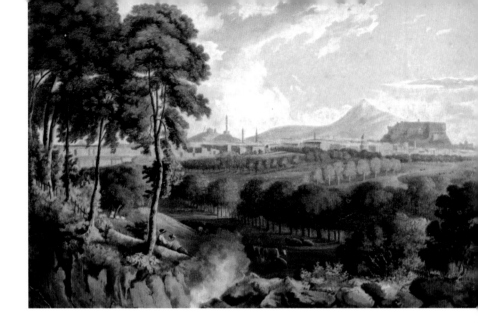

Above right: Edinburgh from Craigleith
This panorama of Edinburgh from the west was popular until the urban spread altered the profile. However, the durable sandstone produced by Craigleith quarry has played a significant role in the development of Edinburgh and Leith. Most of the New Town was built with stone from here, as well as public buildings (City Chambers, Old Quadrangle of University, Parliament Square and the National Monument). The construction of Leith Docks in 1895 was the last major project utilising Craigleith stone, and quarrying had ceased completely by 1942. The massive 360-foot hole was filled in, and Craigleith Retail Park now occupies the site.

Below right: Roseburn Terrace
A contemporary version of this picture could now be taken, as Edinburgh has once again taken to tram travel, but only after much disruption and financial controversy. The new trams began service in May 2014.

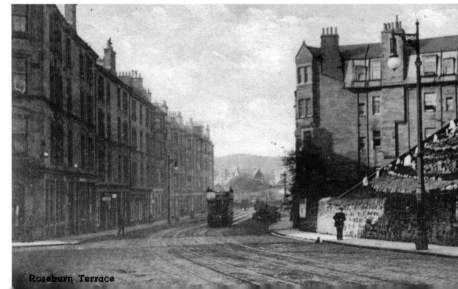

Roseburn Terrace

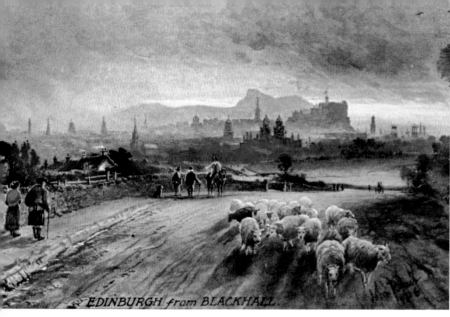

EDINBURGH from BLACKHALL.

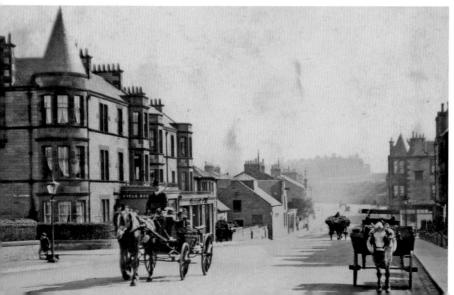

Above left: **Edinburgh from Blackhall**
Apart from the Craigleith quarry, cottages for the quarrymen, the mansion houses of Ravelston House (1790) and sixteenth-century Craigcrook Castle, this area was rural until the railway station opened in 1879. Development then began to spread westwards from Dean to Ravelston and Craigleith during the twentieth century and the community of Blackhall grew up. The hotel and garage on Queensferry Road are built on the site of Blinkbonny Farm.

Below left: **Blackhall Brae**
The Caledonian Railway North Leith line from Haymarket to Granton and Leith (and later branch line to Barnton) passed underneath the Queensferry Road, but the station itself was built over the railway on the south side of the road. In 1951, the line closed to passengers and to goods in 1960, and the trackbed forms part of the North Edinburgh cycle path.

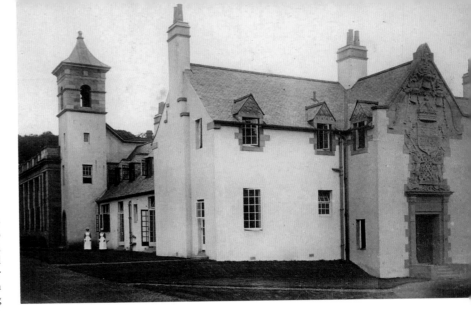

Above right: Royal Victoria Hospital

In 1894, Craigleith House was rented by Dr Robert William Philip, who specialised in treating patients suffering from tuberculosis, as a sanatorium to augment his Edinburgh clinic, called 'The Victoria Dispensary for Consumption and Diseases of The Chest'. The situation of the house and grounds fulfilled the criteria of isolation with lots of sunlight and fresh air, the treatment for early-stage tuberculosis prior to antibiotics, and known as the 'Edinburgh Scheme'. By 1955, when tuberculosis was being successfully cured by drug therapy, the hospital changed to long-term care for elderly patients. In 1960, Craigleith House itself was demolished to enable more suitable wards to be built in 1967 and extended in 1986. Storm damage from a fallen tree was the death knell for the hospital and, in 2012, it was transferred to the Royal Victoria Building at the Western General Hospital.

Below right: Clermiston Road

Clermiston lies on the western side of Corstorphine Hill, between Davidsons Mains and Corstorphine. It is a recent suburb of Edinburgh mostly built in the 1950s, but the land was mentioned in early records as a hunting ground. Clermiston House was built in 1792, but pulled down in 1970 when Queen Margaret University was built. Likewise, the Victorian villa of Clermount was replaced by the Fox Covert Hotel. However, the most interesting 'loss' is that of the bunker in the hollow of Barnton Quarry, on the north-west slope of Corstorphine Hill. During the Second World War, the RAF had a secret operations room. It was then used as an operations centre throughout the Cold War, and lastly it was a designated Regional Seat of Government in the event of nuclear war. It would have made a fascinating museum but a three-day fire started by arsonists has caused so much damage that it has lain derelict for over twenty years.

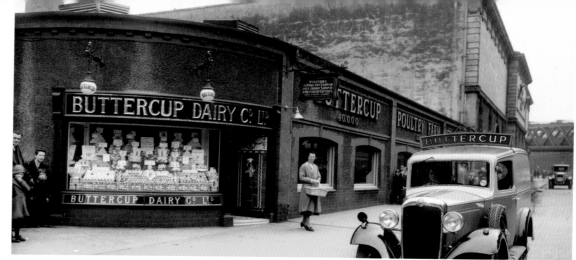

Above: **Buttercup Dairy**

The Easter Road headquarters of the Buttercup Dairy Co. was the third premises, as the business outgrew the previous ones in Elbe Street, then Constitution Street, and consisted of two warehouses, a cold store, poultry farm building, offices, two cottages and a shop. The entrance was adorned by the cheerful, distinctive, and colourful tiles adopted by the company as their 'brand', making all their shops instantly recognisable. The mural, painted by artist Tom Curr, depicted the question 'Do you like butter?', with a little girl placing a buttercup under a cow's chin. Twenty-three of these attractive doorways still survive, following the last Buttercup shop closing in 1965. The Easter Road depot was purchased by Salvensens around this time, and used as a cold store for ten years, until it was sold for housing.

Left: **Tiles of Buttercup Dairy**

Clermiston was the centre of an unusual business venture in the early twentieth century. In 1904, a young entrepreneur, Andrew Young, set up the Buttercup Dairy Co. in Leith, selling dairy products and eggs, which, at that time, were imported. He began to open shops, first in Edinburgh, then further afield until, twenty-five years later, 250 existed. The company decided to produce their own eggs and, in 1922, purchased the 88-acre Clermiston Mains, which developed into one of the largest poultry farms in the world – having 10,000 Leghorns laying up to 200,000 eggs per week. Andrew Young was a staunch Baptist, who ran his business in a disciplined manner, placing importance upon the welfare of both staff and hens, but donating all eggs laid on Sunday to charity. Ultimately, his generosity created financial difficulty for Buttercup, compounded by a major fire and increasing competition, and the Clermiston enterprise was turned over to farmland. He died in 1956 a poor man, which was in keeping with his religious belief. In the 1950s, Edinburgh City Council bought the land for social housing to relieve overcrowding in Leith and Gorgie.

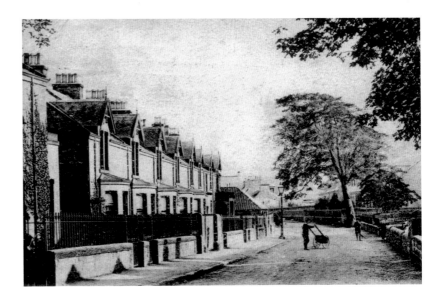

Above right: **Corstophine, 1908**
A mineral well near a cluster of thatched cottages drew visitors to Corstorphine in the mid-1700s, and there were daily horse-drawn coaches from Edinburgh. A later attraction, for which the village became known, was 'Corstorphine Cream', the making of which was described in an old statistical account as: 'They put the milk, when freshly drawn, into a barrel or wooden vessel, which is submitted to a certain degree of heat, generally by immersion in warm water. This accelerates the stage of fermentation. The serous is separated from the other parts of the milk, the oleaginous and coagulable; the serum is drawn off by a hole in the lower part of the vessel; what remains is put into the plunge churn, and, after being agitated for some time, is sent to market as Corstorphine Cream.'

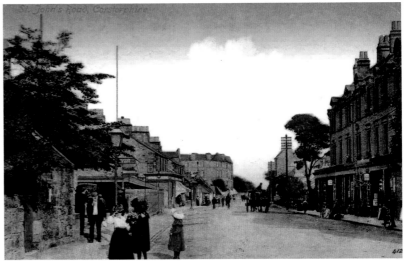

Above left: **St John's Road, Corstorphine**
The original village of Corstorphine has a narrow, winding main street, commensurate with the rural life of past centuries. In the 1800s, a few villas had been built around Corstorphine Hill, but the arrival of the railway, in 1901, was the turning point. The village was engulfed by development during the twentieth century. St John's Road was the main thoroughfare to Glasgow, and remains a traffic bottleneck, despite the Edinburgh bypass.

ENTRANCE TO ST. MARGARET'S PARK, CORSTORPHINE. 239/29.

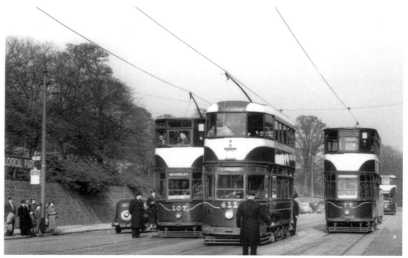

Above right: **Zoo Park Trams**
Thomas Gillespie, an Edinburgh lawyer, founded the Zoological Society in 1909, which was responsible for the creation of Edinburgh Zoo, opened in 1913. The last twentieth–century tram in Edinburgh was in 1956, but history is now repeating itself and the city opened its new tramway in 2014.

Above left: **St Margaret's Park**
This park was laid out in 1927, close to the site of fourteenth-century Corstorphine Castle, which was built on land between two lochs. At that time, it was necessary to be rowed across from Coltbridge to Corstorphine, but, as the water gradually dried up to leave a swamp, a lamp was kept burning in Corstorphine church to guide travellers across the treacherous path. A very old tree, known as the Corstorphine Sycamore, dating back to the era of the castle, stood nearby, but was blown down during a storm in 1998.

Left: **Scottish Nation Exhibition, 1908**
This was held in the grounds of Saughton Park, which at that time was surrounded by fields, although a few houses had been built in Balgreen Road, in 1895. The bandstand and other exhibits were dismantled and rebuilt at Portobello Marine Gardens.

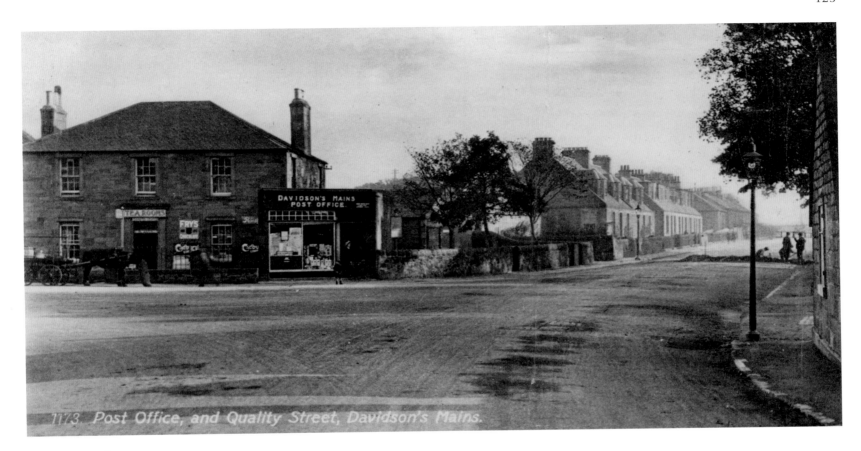

1173. Post Office, and Quality Street, Davidson's Mains.

Davidson's Mains

In 1827, the old hamlet of Muttonholes was made into a village called Davidsons Mains, named after the family of the Muirhouse estate. It included a school and a parish church, which was originally Cramond Free church. Water was collected from a spring on Corstorphine Hill, which involved villagers cutting across ground belonging to Barnton House, a practice the landowners objected to, so permission was granted to lay pipes to a well on the edge of the village, leading to a well, which can still be seen next to the park gate. Like other Edinburgh suburbs, it began to expand once it became accessible by railway, in this case with the opening of the Barnton branch line in 1894.

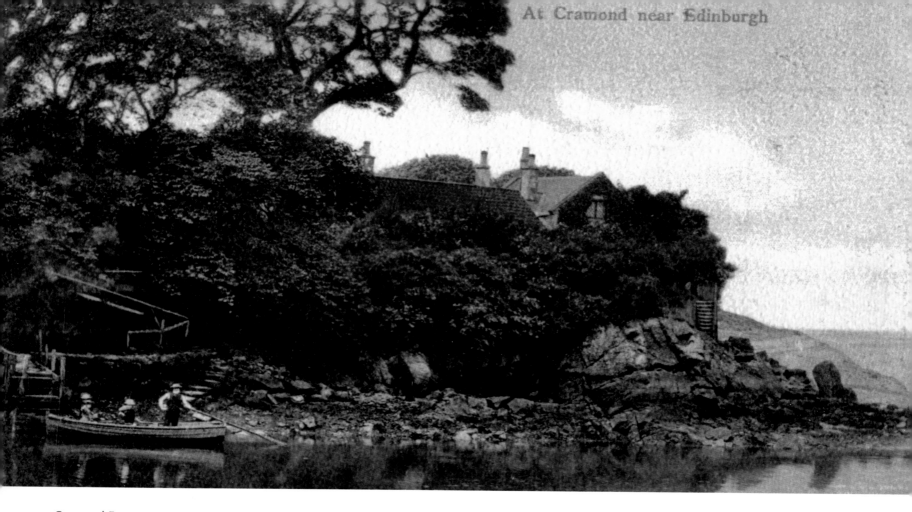

Cramond Ferry

A rowing boat was used for over a century to cross the mouth of the River Almond, from Cramond to Dalmeny estate, owned by the Earl of Rosebery, and in whose cottage the ferryman lived. The service stopped in 2001 after the outbreak of foot and mouth disease. However, plans have been submitted this year by Cramond Community Council to reinstate the ferry crossing.